VOGUE

COLOURING BOOK

D0493272

IAIN R. WEBB

conran OCTOPUS

August 1950
Highwayman cuffs of velvet,
edged with jet, emphasise
wide three-quarter sleeves, on
a swing jacket of a black wool
three-piece. By Spectator.
Grosgrain sailor hat by Pissot
and Pavy at Dickins & Jones.

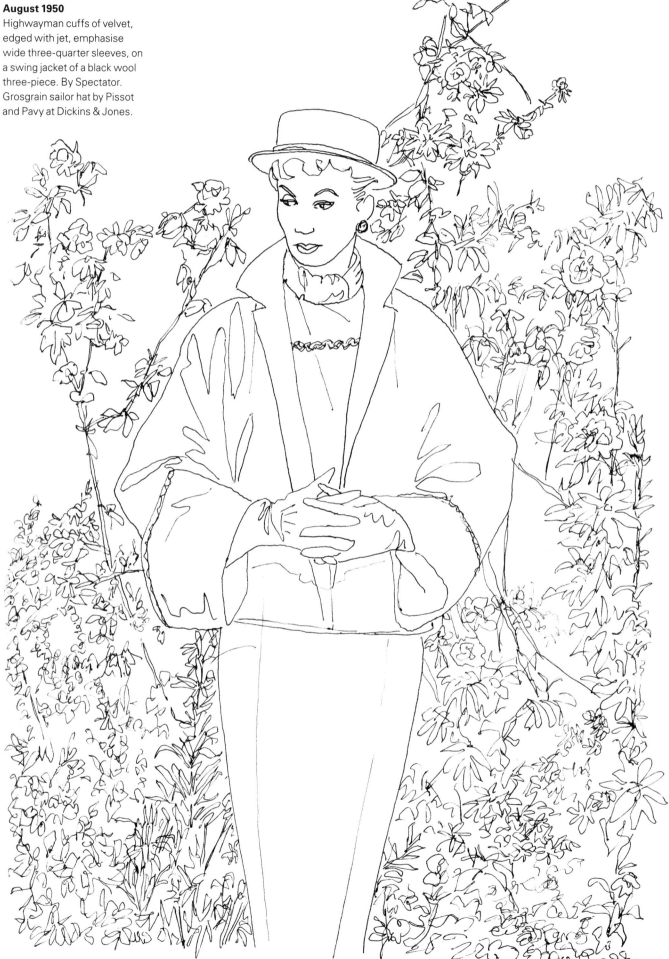

THIS BOOK HAS BEEN COLOURED IN BY

..

4

September 1955
Accessories blend with coloured shoes. The gleaming, vibrant copper-red of just ripe rowan-berries is this autumn's new shoe colour. Wonderful in town with dark browns, evergreens; as the one splash of colour with black or beige; it is superb, too, with almost all country tweeds. Shoes by Bally of Switzerland. The bag has a handle along the bottom for under-arm carrying. By Waldybag.

I have always loved *Vogue* magazine. I remember, as a teenager, receiving my first copy for Christmas. It was the best present ever. I would spend hours poring over the pages, tracing the new fashions along with the models' make-up and hairstyles.

For one hundred years, British *Vogue* has offered the very latest fashions, stylishly editing the outfits presented by designers on the international fashion scene – from Paris, London, New York, Milan, Rome, Tokyo, Antwerp, Madrid and more. Teams of talented fashion editors, photographers, make-up artists, hair stylists and their assistants have planned and plotted to produce images that will inspire, surprise and delight the reader, transporting them to Planet Fashion.

For this first *Vogue Colouring Book,* it seemed appropriate to focus on the 1950s. It was the moment the world went from black and white into colour, and this revolution, as always, was documented by *Vogue*. It was a time of exciting change, with designers creating new silhouettes – from the 'wide, crinoline-style skirt' to the 'long, flat jacket' – and going mad for synthetics – 'nylon taffeta' and 'rayon dupion'. It was an era when fashion photography looked more spontaneous and travel for pleasure became popular ('the puff of a whim is now almost enough to whirl us anywhere on earth,' to quote *Vogue* in May 1955), so models posed in new and exciting locations.

The 1950s was an era of elegance and newness, and these two notions appeared time and time again in the captions that accompanied the fashion pictures. Each drawing in this book comes with a snippet of the original text with which the *Vogue* editors explained exactly why their readers needed that must-have 'slim but easy suit' or 'delicious garden-party dress'. These captions reflect their time and are often highly amusing in hindsight.

On my first day at St Martin's School of Art in London, where I studied fashion design (I dreamed of being a designer), we were given old editions of *Vogue* magazine and told to copy the fashion models. It was an opportunity for our lecturer to see our illustration skills and a way for us to learn to draw fabrics – how they look, how they drape and fold around the body. I still have those sketches.

I loved drawing from *Vogue,* so imagine how thrilled I was to be asked to create this new *Vogue Colouring Book* and once again spend my days illustrating the models posed in their best finery.

Now it's your chance to be the designer, and to colour in your own versions of the latest looks – you can choose to follow the descriptions of the original garments or create crazy new colourways of your own. Why not transform a plain suit with fabulous florals, zany stripes or checks, or transport the models to even more exotic locations by drawing in your own backdrops?

I made this *Vogue Colouring Book* for my fashion-obsessed teenage self. I know I would have loved to receive this book as a gift and I hope you think it's the best present ever. Now where did I put my colouring pencils?

— *Iain R. Webb*

March 1951
The Chignon Hair is the most important news in hairdressing since 1948 when hair became short. The chignon is usually an attached piece (your own hoarded tail perhaps) or frankly artificial. The hat is a demure pill-box worn forward and tilted; in navy blue Lizérie straw, trimmed with two crossed quills by Vernier.

→ **January 1956**
First sight of Spring. *Left*: Loose jacket, tiny stole – this suit in blue, black and white tweed by Frederick Starke. *Right*: In town today – knife pleats and a long matching stole. Suit, by Koupy, is in fine black, white and grey worsted, soft as the Afghan's coat. Hats by Otto Lucas.

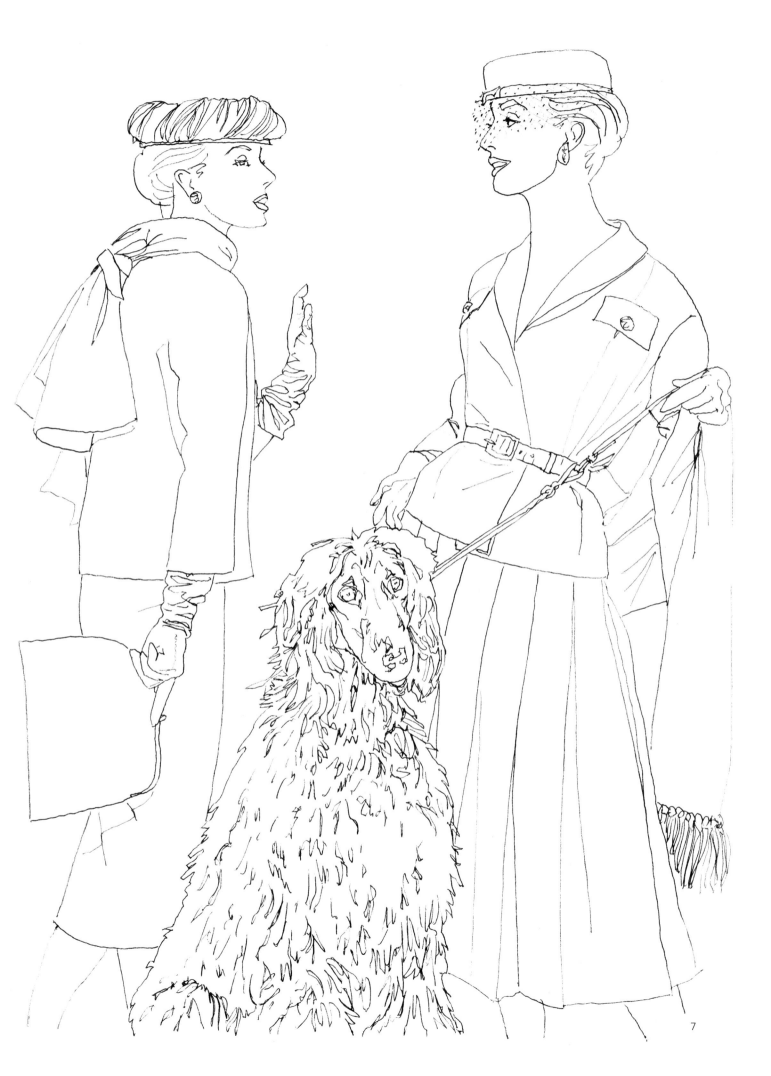

May 1954

The wide cummerbund and the billowing print are two Paris themes combined in this delicious garden-party dress by Frank Usher. It is floating silk organza printed with pink and green flowers on a grey-white ground; girdled with a moss-green organza cummerbund; its roll-collared boat neck tying at the back. The untrimmed green hat has a slightly cloche brim, a tiny crown.

→→ July 1951

A summer evening dress should be fragile in colour or texture, should have a freshly laundered look. In the Italian Conservatory, Glaslough Castle, she wears a dream dress for holiday packing. The wide skirt is of nylon taffeta like lemon mousse, the bodice black silk jersey. By Roecliff and Chapman.

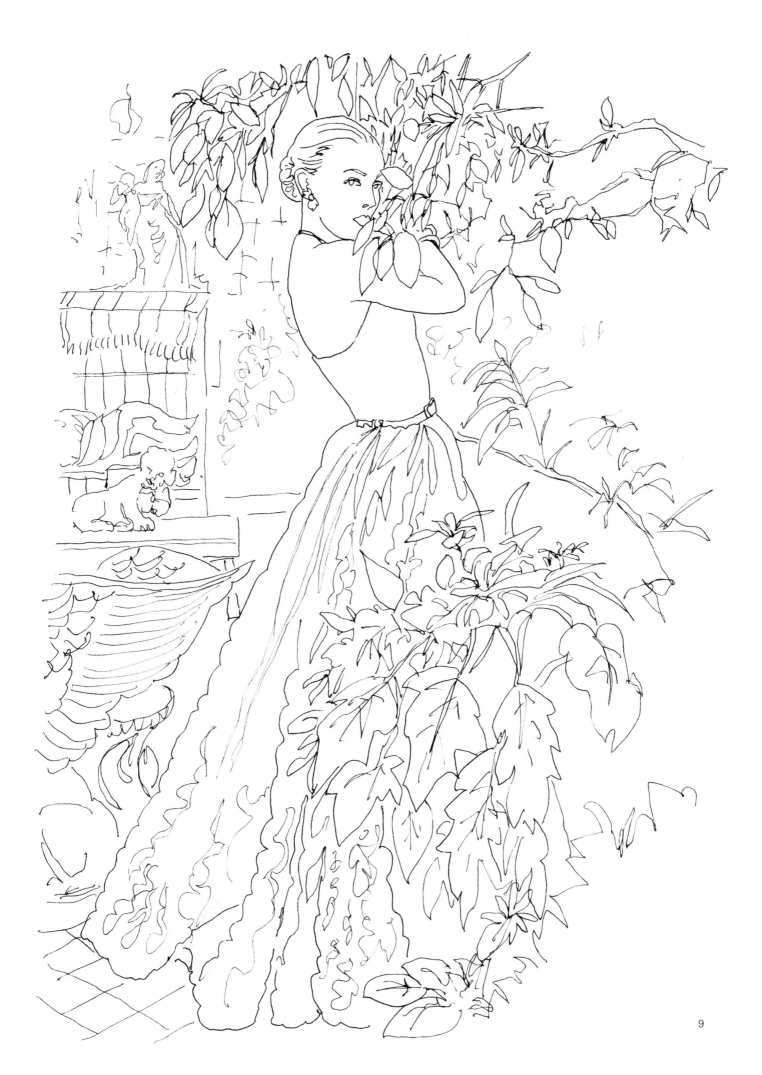

November 1953
From day to evening – in tweed.
A black-and-white tweed dress,
sheath-line, beltless, news in
itself for evening. By Susan
Small. For evening, we twinned
together jet and pearl chokers,
jet earrings.

August 1955
Cheetah, becoming colouring – cream beige with soft brown markings – is the fashion tip for race meetings. (Perfect too for mornings in town.) Here, ideally, in a coat cut straight and loose, its own belt tied sash-wise at the waist. From S. London. Stone-coloured cloche by R.M. Hats, sand-coloured pochette from Fior.

March 1950
The London way is a way of
its own. The clothes are good
mannered. Great allure in a
short evening dress with corset-
tight bodice of white guipure
lace; hip-swathed, back sashed
skirt of navy blue figured silk.
(A lace-collared bolero makes it
a cocktail suit.) By Hardy Amies.
Erik cartwheel hat.

→→ **December 1954**
The new party look. Entrance
and exit making: here, a vividly
memorable coat in pomegranate
red brocade mixing with a collar
and cuffs of brighter, yew-
berry red velvet (mixed reds
are news). From the close-cut
top stems a sweep to envelop
most beautifully any shape of
dress. By Roecliff and Chapman.
Triangular rhinestone earrings by
Luciana of Rome.

November 1951
Balenciaga's blown-up hems.
Natural successor to last year's
inflated skirt. Dipping at the
back, curving up in front,
the black taffeta hem balloons
out below long, lace-covered,
taffeta sheath.

→ → **September 1952**
This is the sort of basic, mainstay
suit every wardrobe needs, not
that you'll ever see it in your
wardrobe but out and about in
town and country, or travelling
anywhere. The fabric, a classic:
steel-grey Saxony flannel
(need we say more?). By Hebe
Sports. The hat for it: a red
felt Garbo. Photographed at
Pinewood Studios.

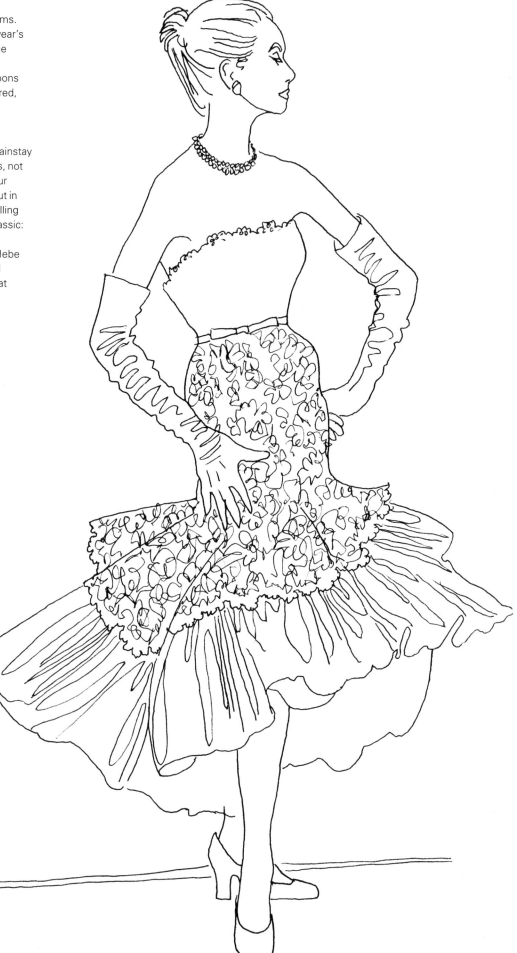

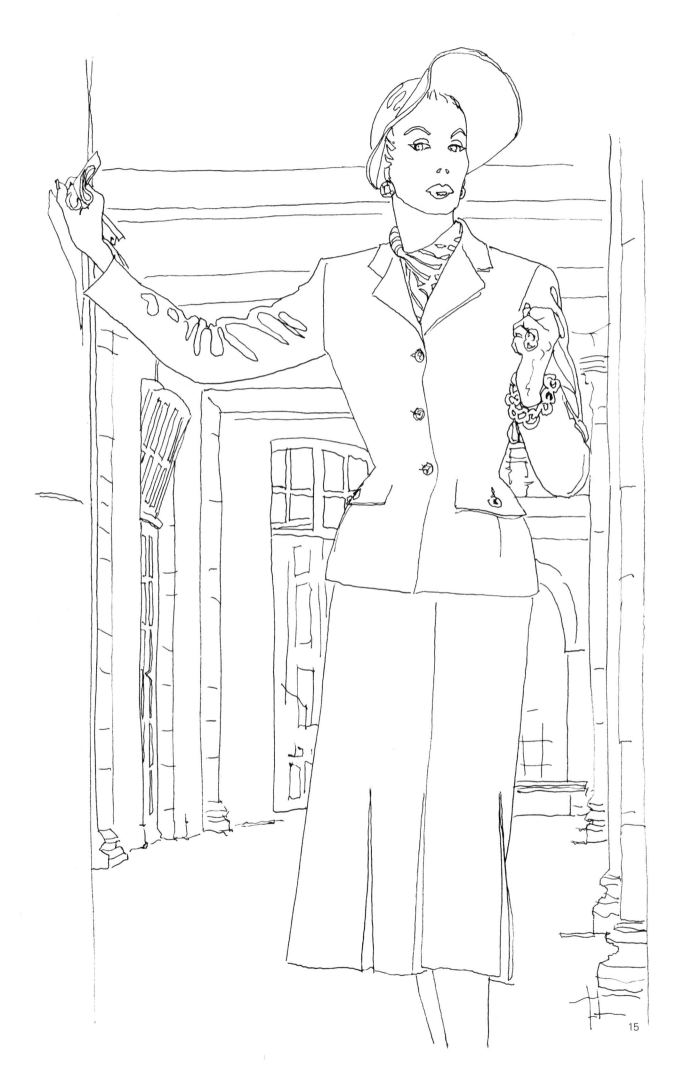

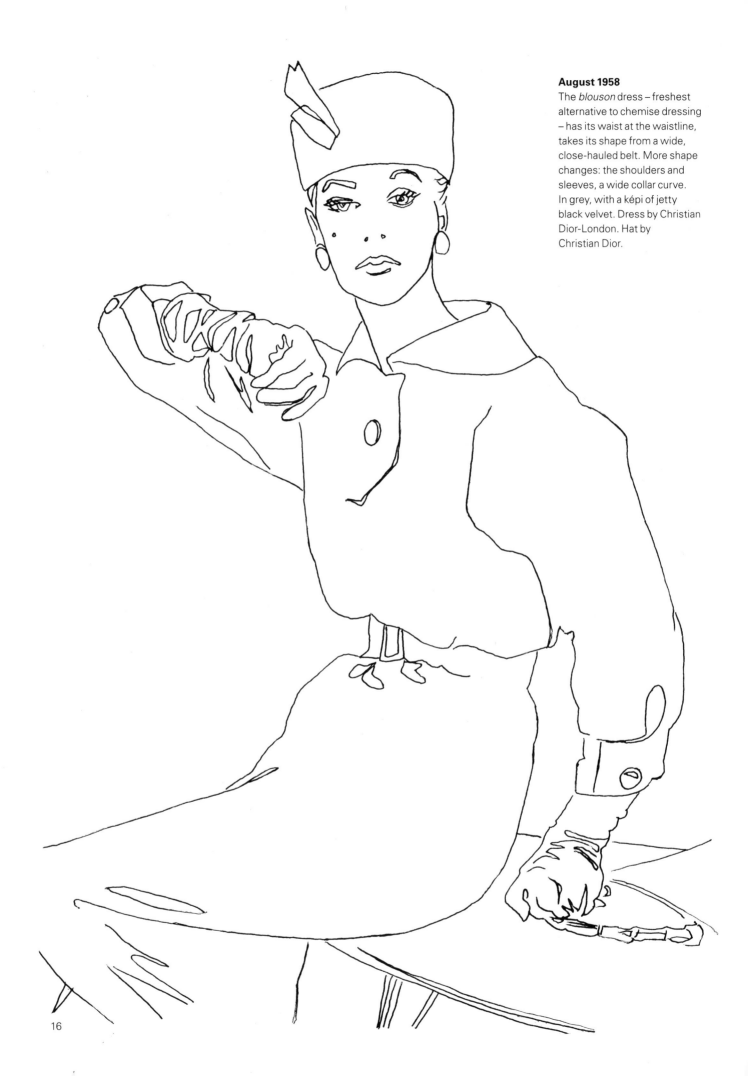

August 1958
The *blouson* dress – freshest alternative to chemise dressing – has its waist at the waistline, takes its shape from a wide, close-hauled belt. More shape changes: the shoulders and sleeves, a wide collar curve. In grey, with a képi of jetty black velvet. Dress by Christian Dior-London. Hat by Christian Dior.

March 1958
The look from Paris. An
enchanting mob-cap of black
organza flower stems trimmed
to a diminutively ragged fringe:
from Laroche, who showed
many such deep helmets and
fragile cloches, all of them
young-looking, very pretty.

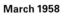

March 1956

Charles Creed shows a
tailored collection of perfect
workmanship, loving detail
and unexpected colour touches,
faultlessly and inimitably
London-bred. This dress and
jacket in Linton's herringbone
tweed: the dress straight,
belted; the jacket narrow, barely-
waisted, with widely-cuffed
sleeves and shallow, hem-level
pockets. The colour notes –
a cravat of stiff spinach-green
satin organza. Simone Mirman's
shiny green boater.

→ → **April 1959**

The Chanel prototype-cardigan
suit with a shirt that *belongs*, an
impeccable show of cuff above
each wrist. New: the plaid tweed
in tandem with black and white
checked silk. Worn here by
Comtesse Guy d'Arcangues…
photographed, for the first time
since its restoration, in the Hotel
Lauzun, on the Isle St. Louis.

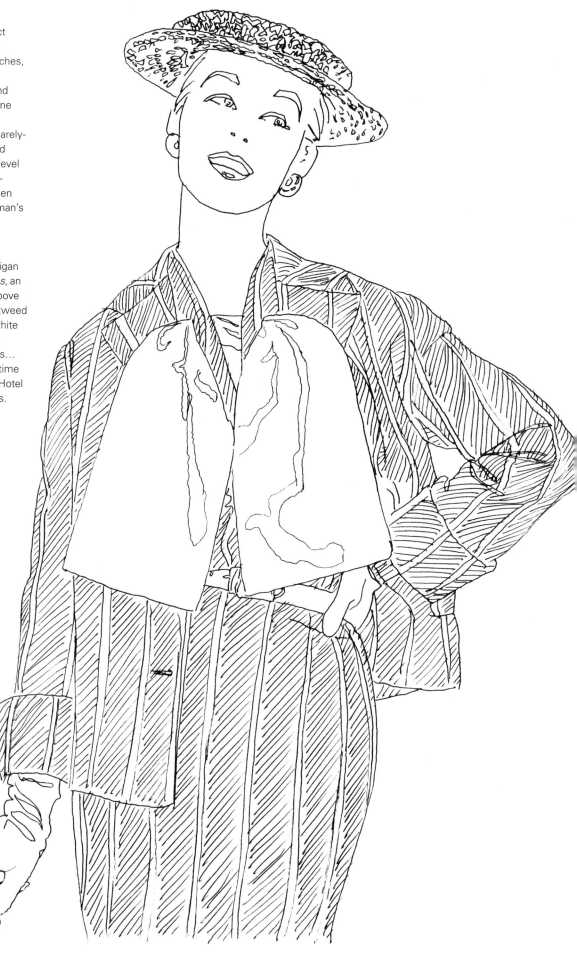

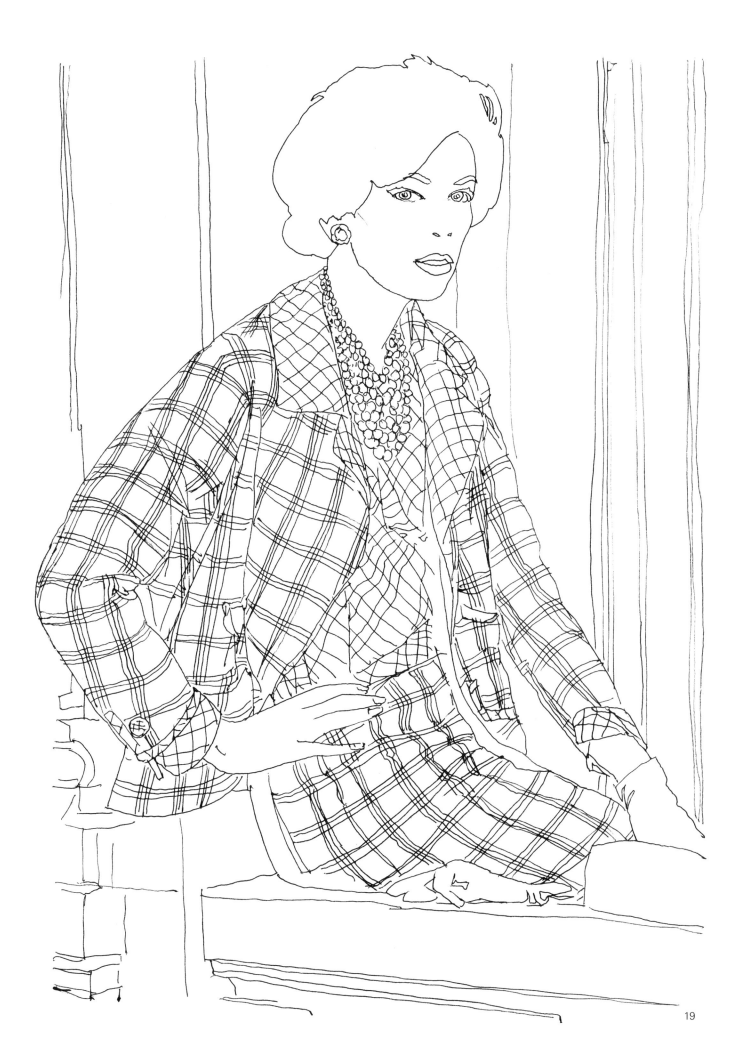

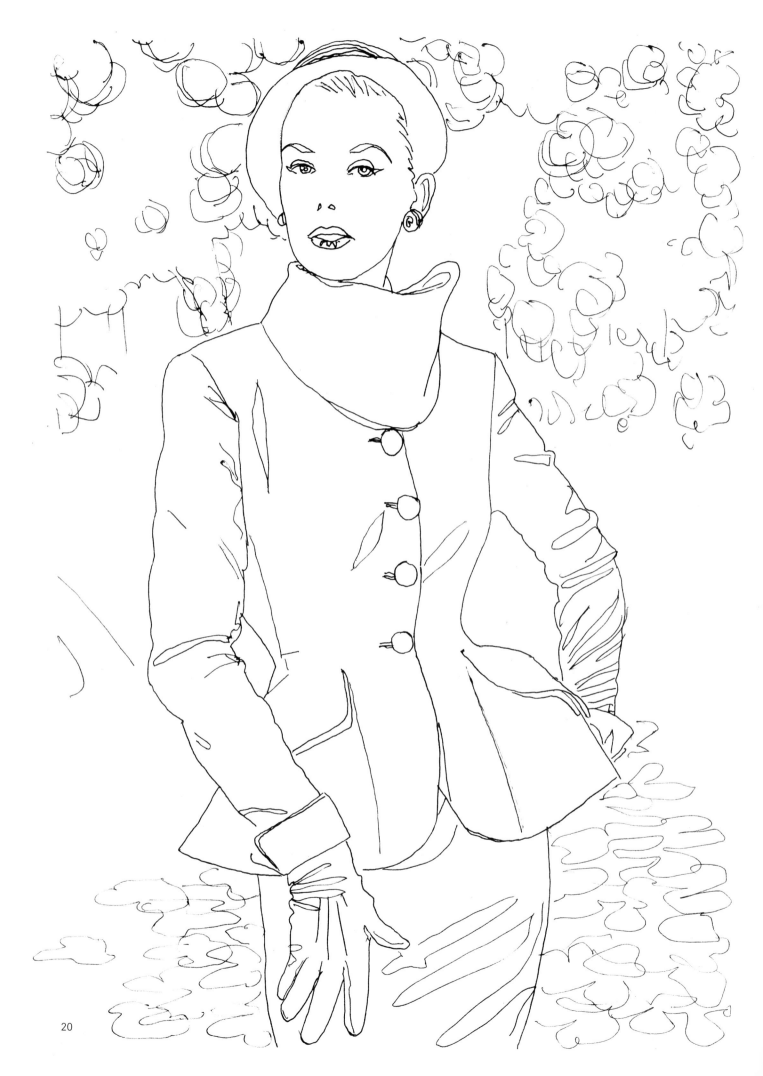

← **September 1951**
The English suit this year is a slim *but easy* suit. Skirts are narrow but not so that you cannot take a reasonable stride. Lachasse's 'Brigand' collar, stiffened, throat masking. The basque, jutting in front, has a hacking-jacket slit at the back – typical of his beautiful Collection. Irish green fine woollen by Bradford and Perrier.

November 1951
Paris Trends. Already the most striking Paris features… Penguin sleeves starting below the elbow, give an almost cape look to a loose coat of charcoal mohair. By Spectator Sports. High-crowned hat, by R.M. Hats at Harvey Nichols.

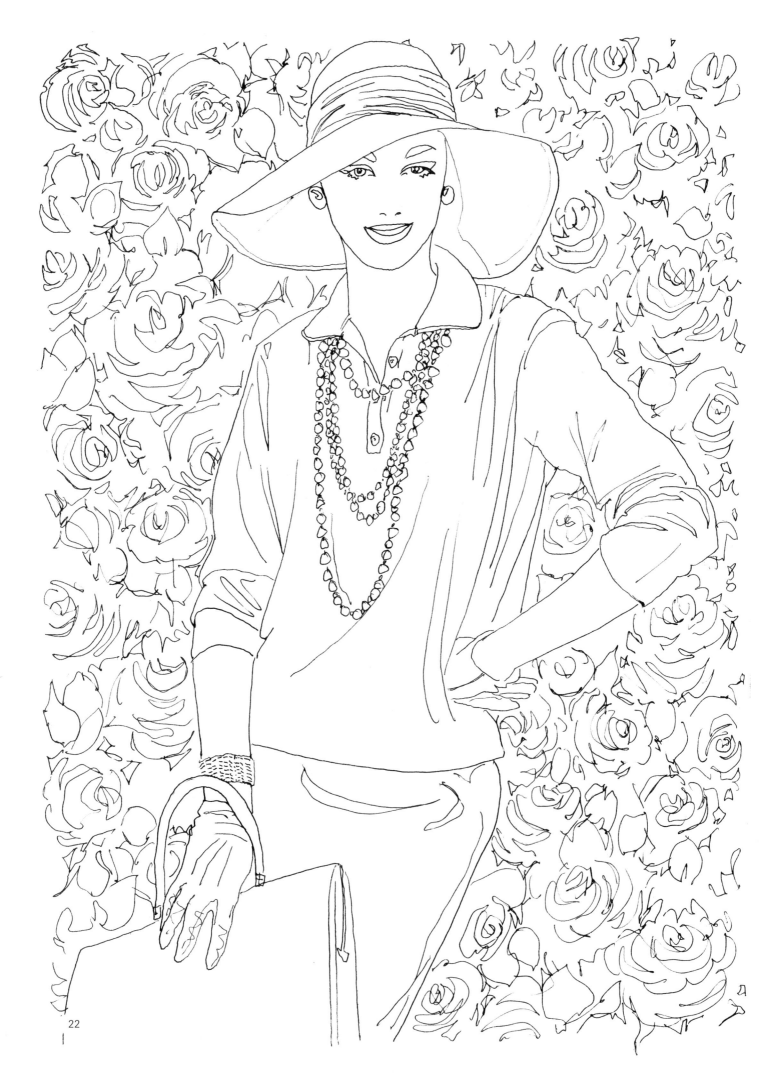

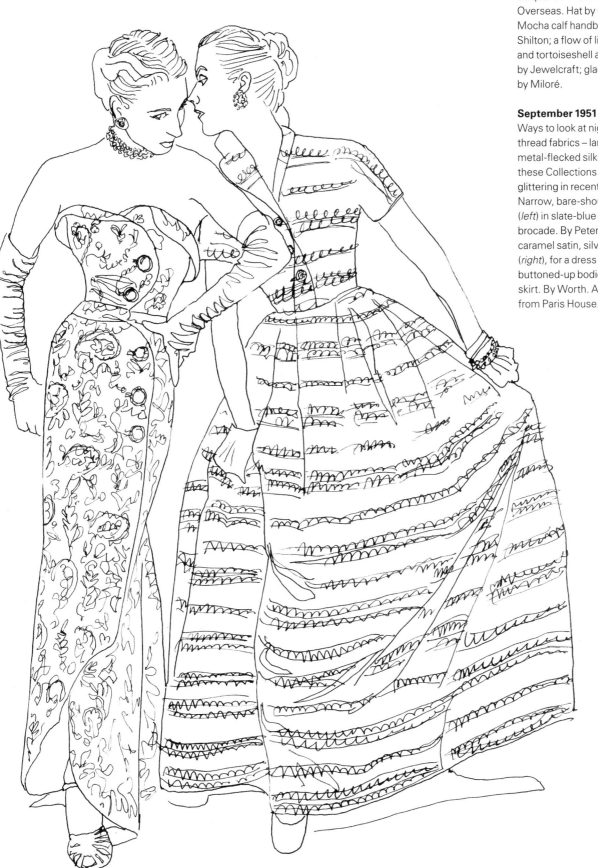

← ← March 1959
The knit-news is in the fibre. Silk simply shaped in a shirt-topped outfit. Its charm – an unadorned sophistication emphasising the eloquence of the silk. By Matita Overseas. Hat by Otto Lucas. Mocha calf handbag by Jane Shilton; a flow of linked pearls and tortoiseshell and gilt ropes, by Jewelcraft; glacé kid gloves by Miloré.

September 1951
Ways to look at night. Metal-thread fabrics – lamé, brocade, metal-flecked silks – make these Collections the most glittering in recent memory. Narrow, bare-shouldered dress (*left*) in slate-blue and copper brocade. By Peter Russell. Stiff, caramel satin, silver-brocaded (*right*), for a dress with demure buttoned-up bodice, sweeping skirt. By Worth. All jewellery from Paris House.

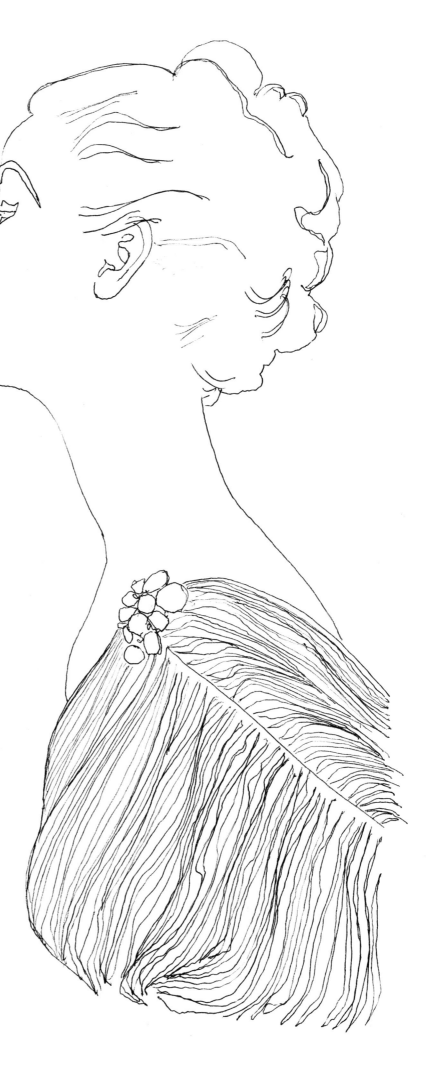

January 1953

We star the hairstyles not fixed
and immutable...styles of line
and distinction plus adaptability...
you see the hair straight from the
hands of Riche; from the side, all
grande dame elegance waved
up and back to give the utmost
flattery to a curving neck and a
fine-boned profile; from the back
a controlled fusion of curls.

→→ **December 1959**

Christmas in the country.
A classic country suit with a
couture look in Burma-green
tweed, with yellow, orange
flecks. It has an easy-fitted
jacket, a slim skirt. By Mattli
Ready-to-Wear at Liberty's.

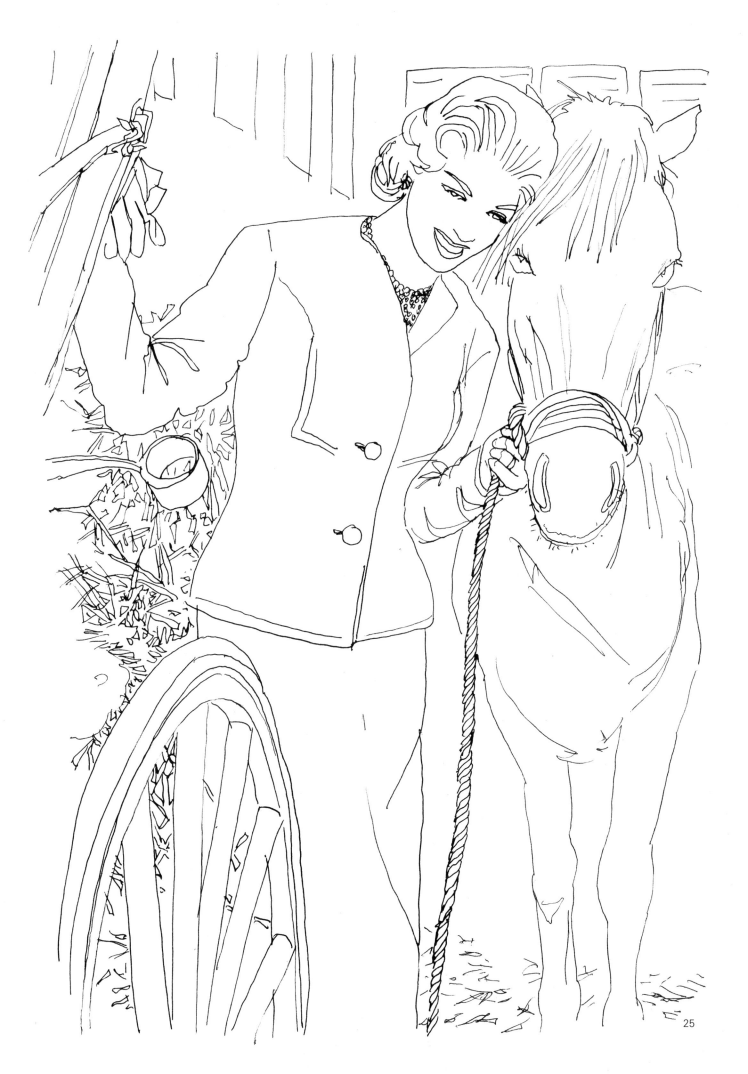

December 1957

Christmas Colour. John Cavanagh's geranium red for evening. Skirt and jacket of velvet, taffeta top softly draped, velvet banded. Simone Mirman's satin beret worn with a huge gilt brooch set with rhinestone: Fior. Bracelet by Adrien Mann. Max Factor's Flame Red lipstick.

→ → **April 1959**

The Season's great evening dress, its effortless simplicity making it for ever a breath-taking beauty: in pure silk organza, a deep fichu wrapping shoulders sleeved to the elbow, the skirt gathered in a soft bell. Christian Dior-London. Lipstick Dior No.9. London setting: Felix Harbord's jade-green drawing room.

26

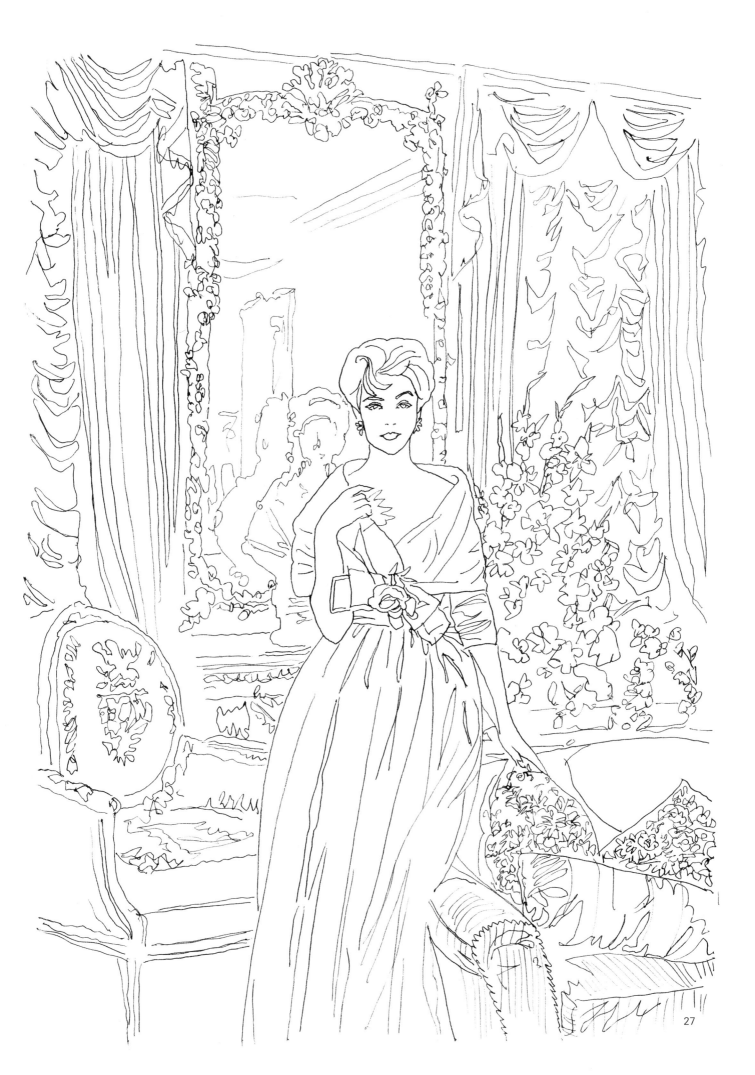

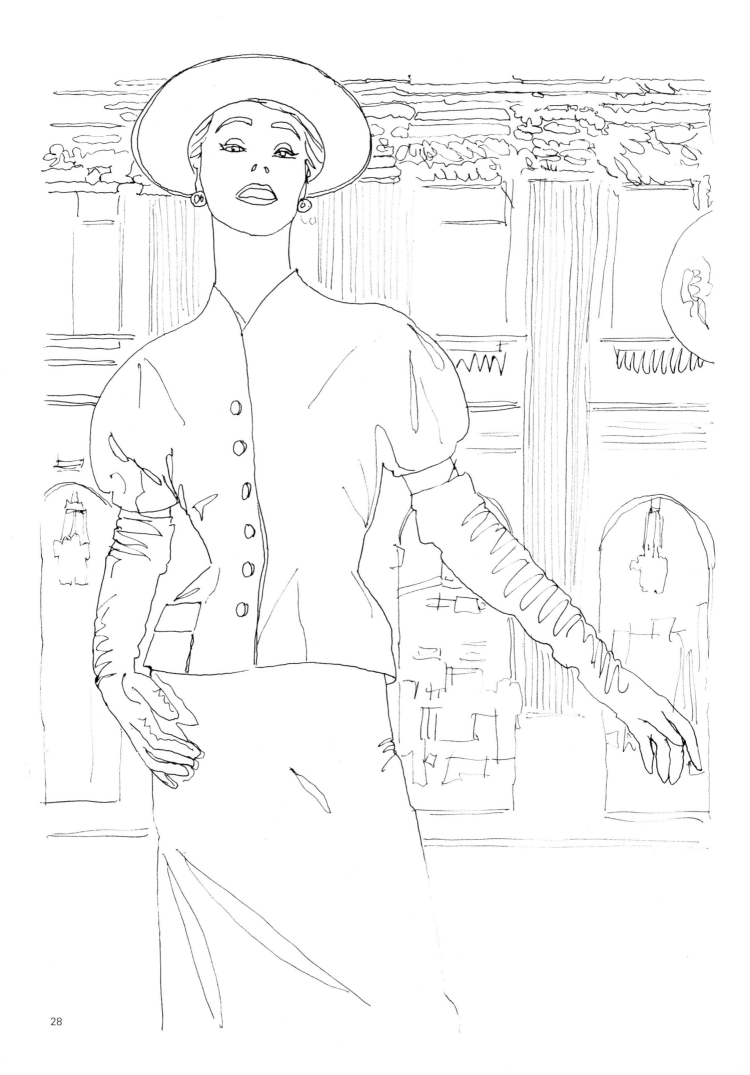

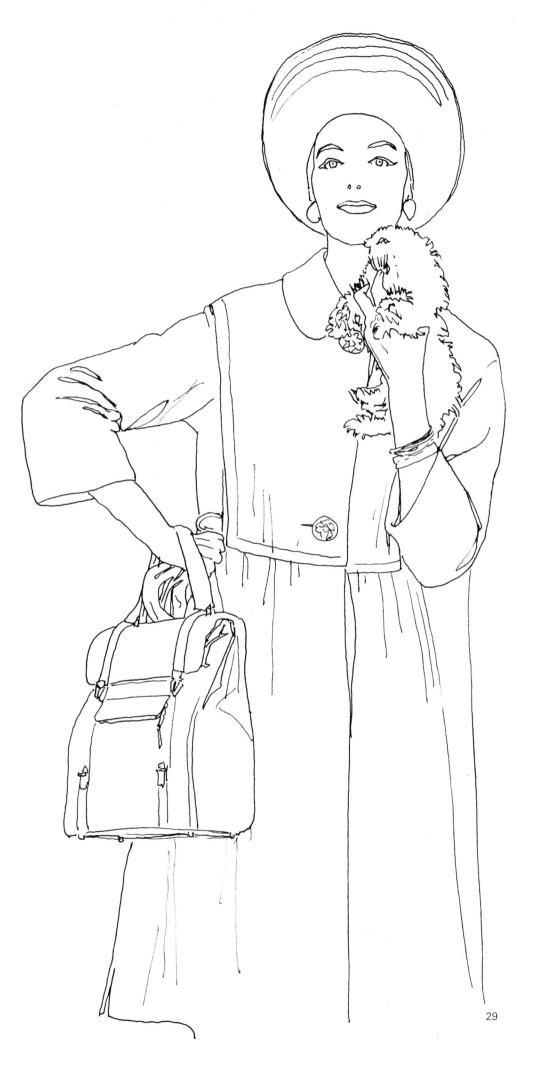

← March 1953

The inflated bodice on Dior's black 'tulip' suit, padded to curve out round the bust, and to swell at the shoulders into short puffed sleeves. The closely moulded waist slides into a straight stem skirt. Long black gloves; upturned pork-pie hat of shell-pink straw.

February 1959

Two credits for this coat: its colour and its shape, both the newest and gayest possible. In pale golden nasturtium wool, the coat has a tiny collar and a deep yoke that extends almost to waist level. By Dereta. Melon-shaped hat in bright nasturtium suede at Rudolf. Huge bag in orange nappa, by Bagcraft. Earrings by Jewelcraft.

November 1957
Black dress, black jacket –
mainstays of a winter life
– in a wonderful heavy black
wool with a hand-knitted look.
The slim sheath is cap-sleeved;
the jacket, softly bloused,
crosses to knot frontwards in
a small bow. By Rima. Beret of
black faille by Otto Lucas. Gold
tasselled brooch and a dozen
gold bracelets by Kutchinsky.

→ **May 1954**
Blue, it's the fall-for colour.
Wedgwood blue is *Vogue*'s
fine-china shade to head this
pretty summer. Wedgwood
blue coat in slubbed wool, light
as china, over a dress of cotton
lace (ideal going-away outfit);
coat by Dorville; dress at Harvey
Nichols. Wedgwood Jasperware
from Gered.

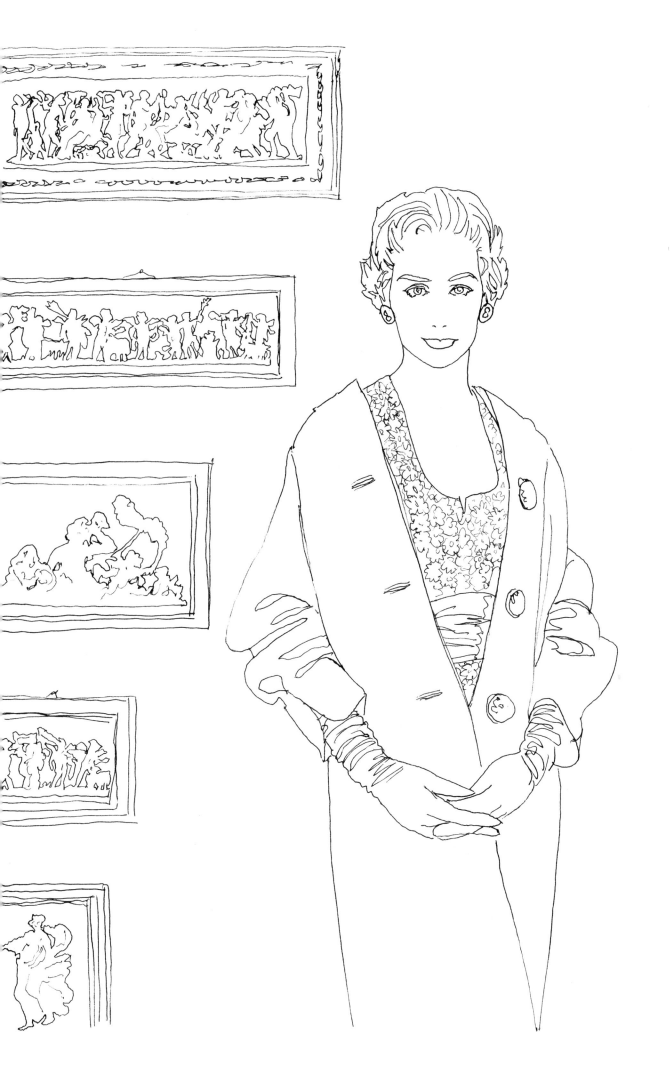

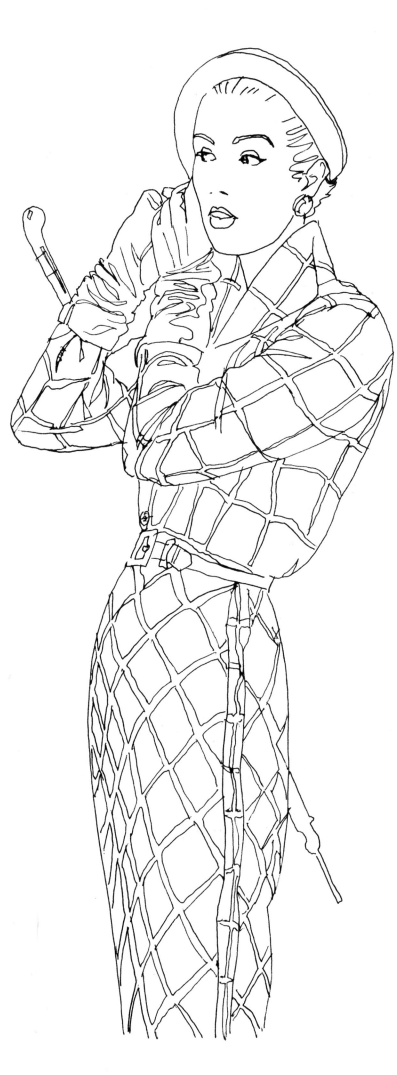

September 1950
Incoming fashion…starring fabrics. Plaid wool – brown overchecked with white and green. An all-day dress to team with plain accessories; skirt's plumb-line straightness emphasised by vertical bands at side-seams. By Marcus at Dickins & Jones. Velour hat from Agmar.

→ **March 1958**
Chanel look in navy jersey. For a spanking double-breasted suit defined by a vivid red nappa bag, white paper panama cloche, navy bound. Suit by Koupy. Background mural painted by Gillian Ayres at Hampstead Girls' School.

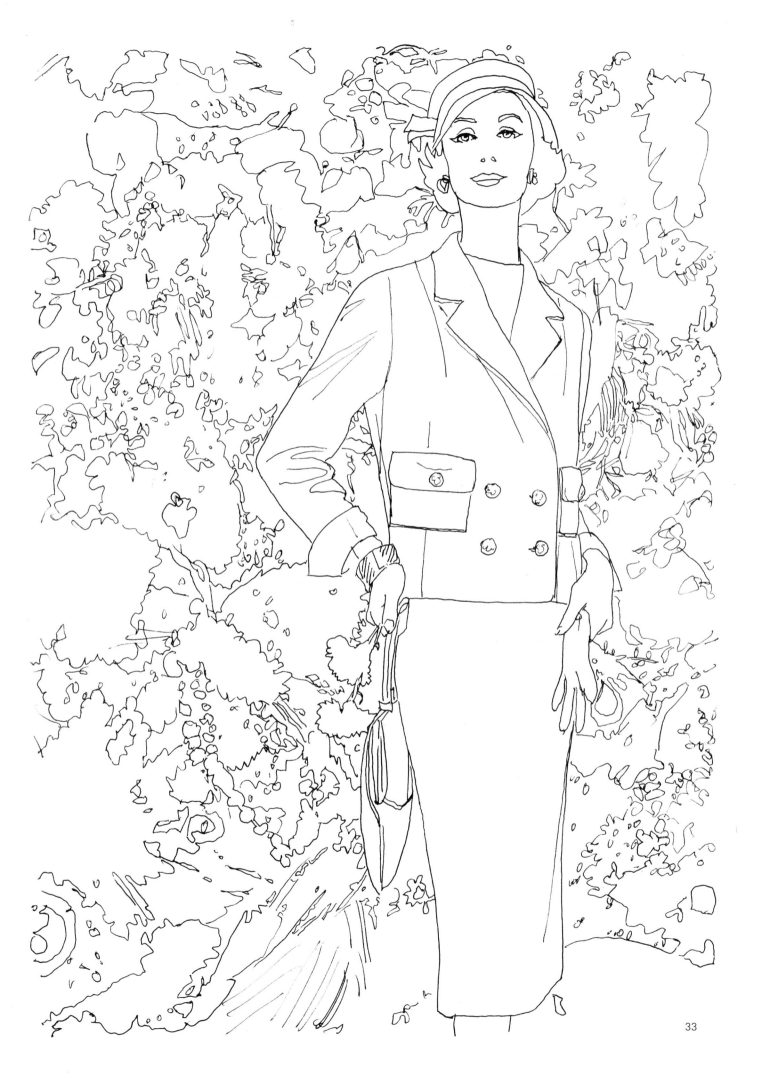

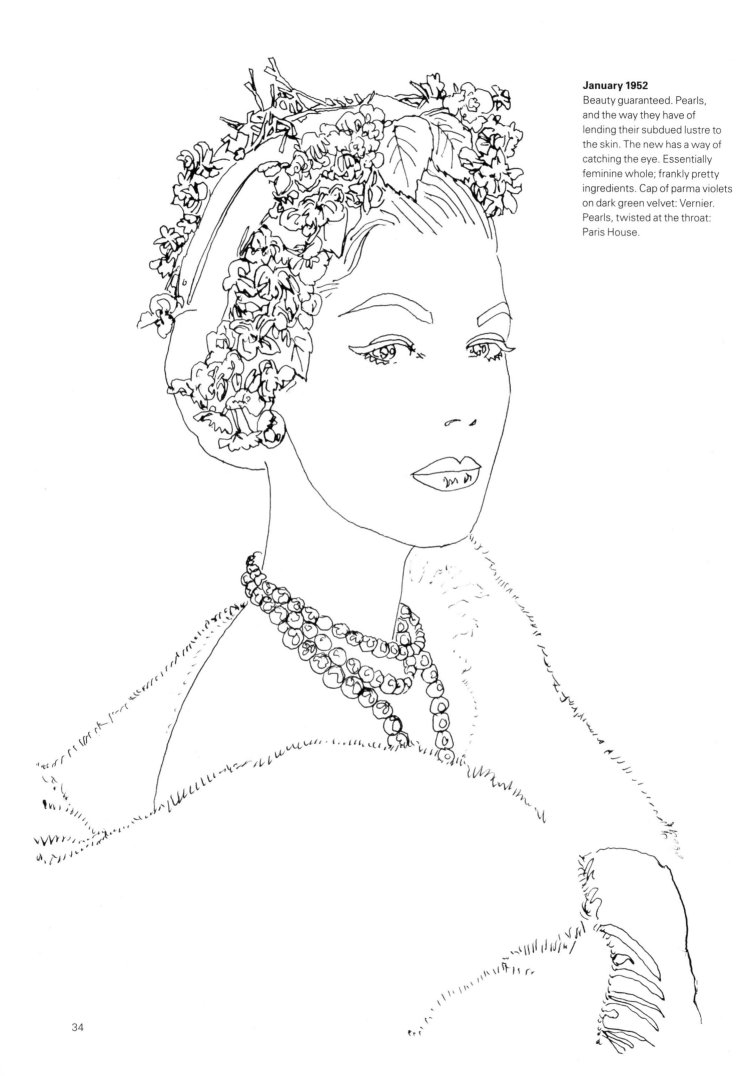

January 1952
Beauty guaranteed. Pearls, and the way they have of lending their subdued lustre to the skin. The new has a way of catching the eye. Essentially feminine whole; frankly pretty ingredients. Cap of parma violets on dark green velvet: Vernier. Pearls, twisted at the throat: Paris House.

March 1956

Left: Worth. Big artificial roses give a splash of colour to pale suits and dresses: rose-printed fabrics abound – like this beautiful *chiné* silk paper taffeta, making a young, romantic short evening dress. *Right*: Hardy Amies. For evening, bows are a recurring detail. The short evening dress is in exquisite black re-embroidered Chantilly lace, over a bouffancy of stiff white net.

35

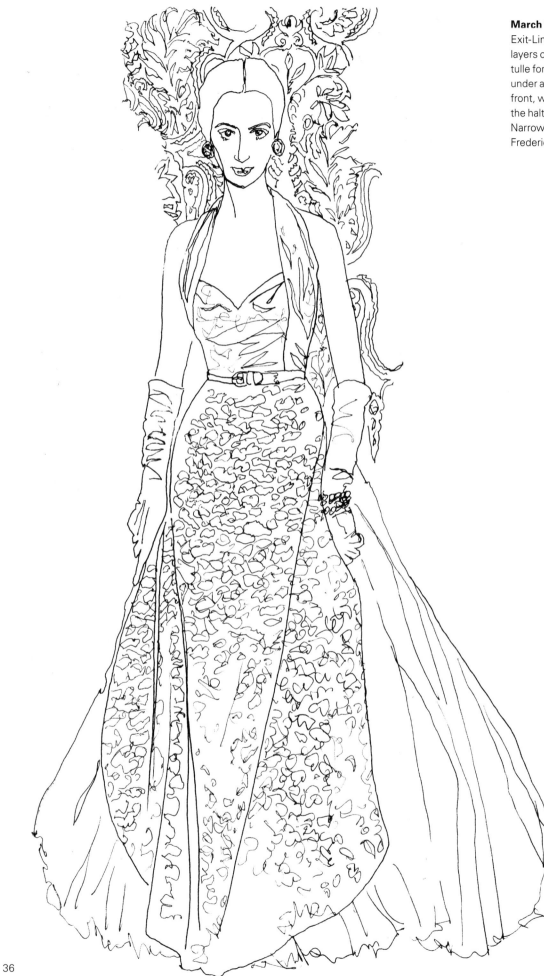

March 1951
Exit-Line Ball Dresses. Billowing
layers of white and primrose
tulle form a vast harem skirt,
under a gold brocade apron
front, which is cut in one with
the halter-necked bodice.
Narrow gold leather belt. By
Frederick Starke.

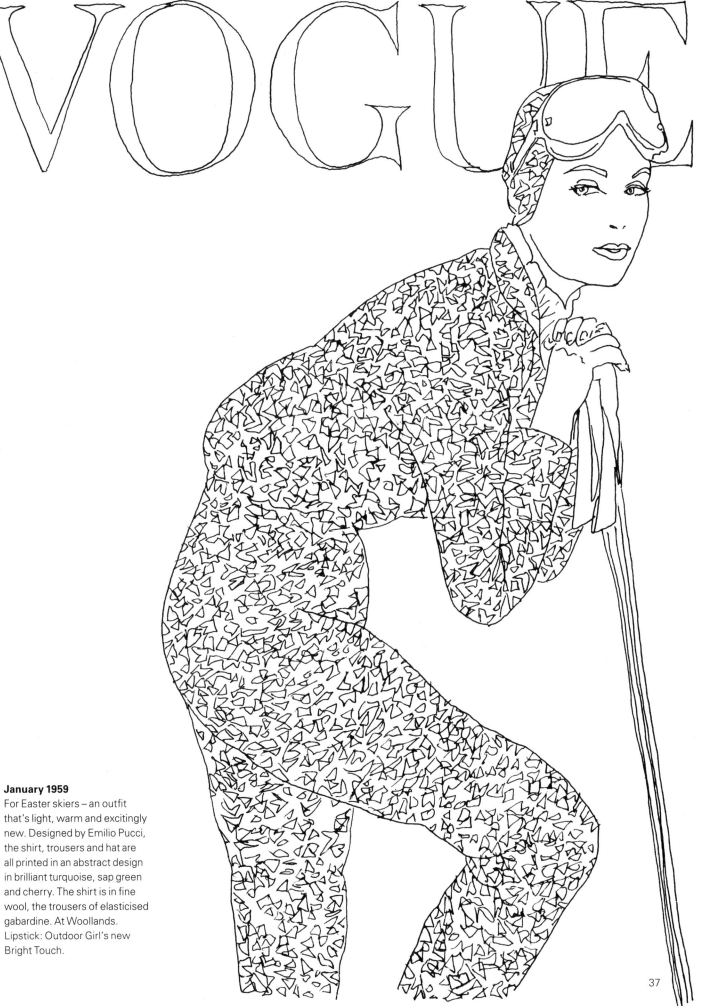

VOGUE

January 1959
For Easter skiers – an outfit
that's light, warm and excitingly
new. Designed by Emilio Pucci,
the shirt, trousers and hat are
all printed in an abstract design
in brilliant turquoise, sap green
and cherry. The shirt is in fine
wool, the trousers of elasticised
gabardine. At Woollands.
Lipstick: Outdoor Girl's new
Bright Touch.

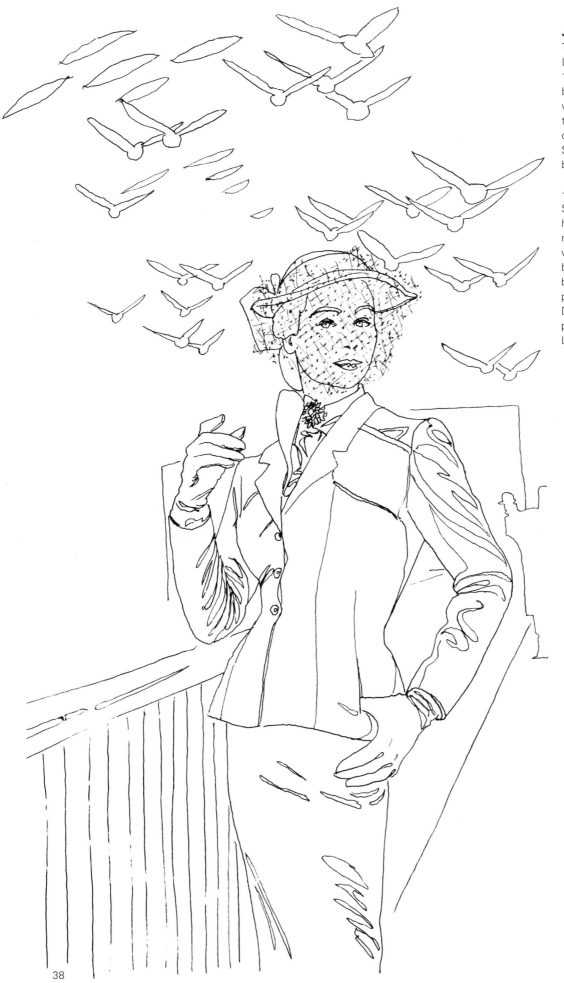

The Visionary Gleam. In the
Lion and Unicorn Pavilion [at the
1951 South Bank Exhibition],
beneath a flight of plaster doves
which wing their way across
the roof, a simple grey covert
cloth suit with a narrow slit skirt,
Simpson. Champagne felt hat
by Aage Thaarup.

→ **March 1957**
Suits with belts. Dior's *vareuse*,
here belted unemphatically, in
navy blue basket weave wool,
with a wide neckline prettily filled
by a chiffon blouse in periwinkle
blue. Jewel note: the dragonfly
pin on the lapel. Navy shoes by
Dior-Delman (Roger Vivier); big
periwinkle straw hat, by Dior, in
London at Simone Mirman.

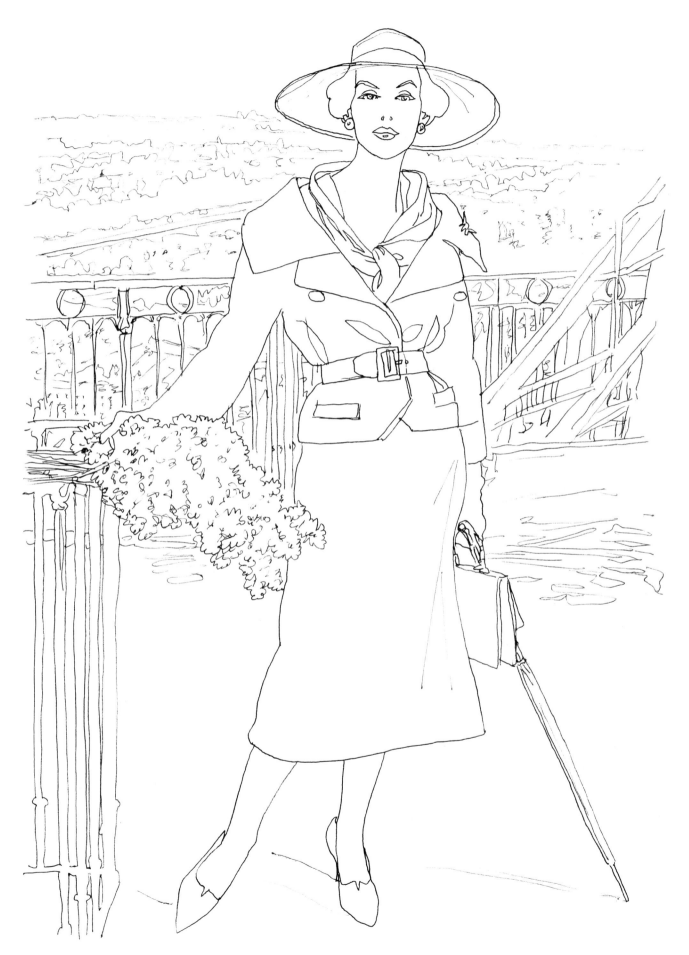

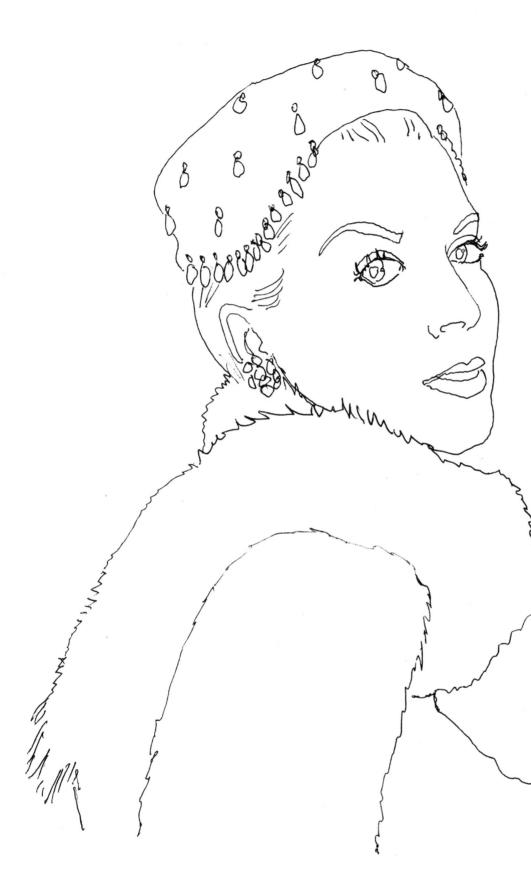

January 1953
A woman looks to a hat for flattery perhaps more, and more often, than anything else. And with reason: here a little black velvet pill-box, straight but unsevere, with a crescent curve, dipping sides, hung with crystal rain-drops that tremble with every turn of the head; the one demand it makes – smooth hair. By Vernier.

→ **December 1951**
News for evening. Balmain's youthful ball dress with bold plaid polonaise of taffeta. The vivid green bodice laces up the back to make perfect a near-perfect young figure. Lipstick is Elizabeth Arden's Redwood.

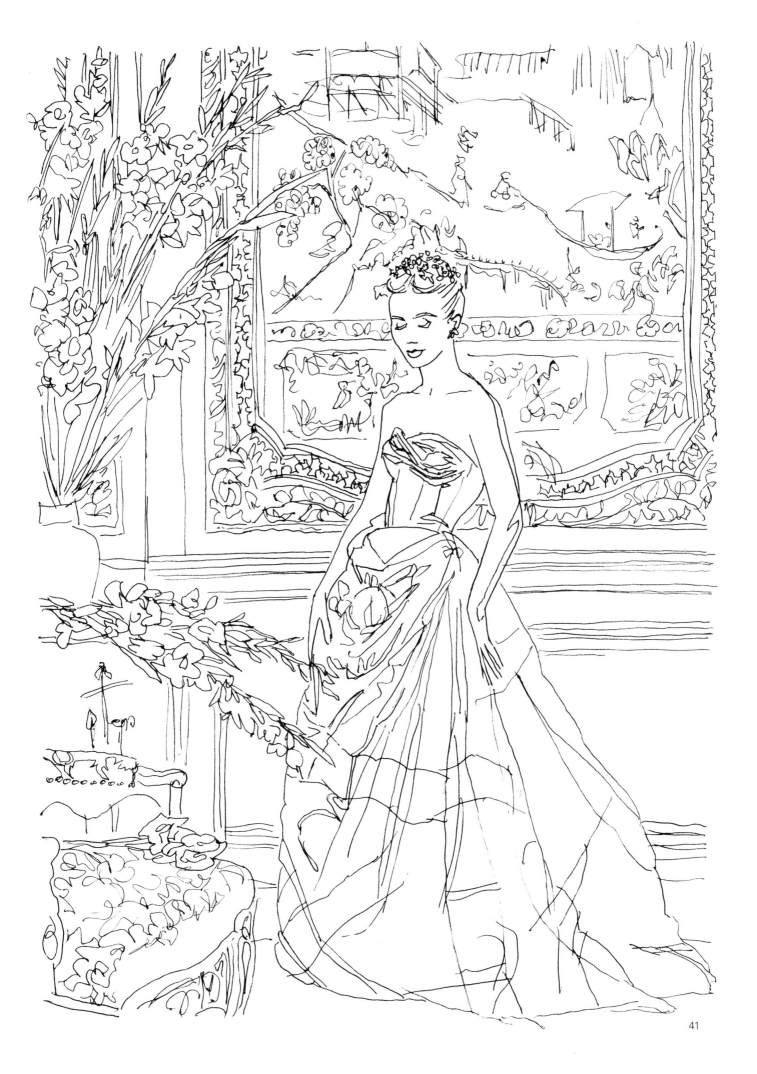

March 1957
The Oriental Slant. Dior uses copper-brown silk with a tiny geometric print, for an eastern look afternoon tea dress with the side-slit and narrow underskirt that recur again and again. (N.B. the slightly longer skirt; the waist, supple but not shapeless.) Black sphinx-shape hat, by Dior, in London at Simone Mirman. Shoes by Dior-Delman (Roger Vivier).

→ **June 1951**
Summer Textures. Broderie anglaise makes a welcome return to favour this summer – in its traditional white for evening, often coloured for day; and as a motif woven or printed on many silks and rayons. Snow White broderie anglaise dress and navy redingote for gala summer occasions. Tulle trimmed hat by Elizabeth Hellier.

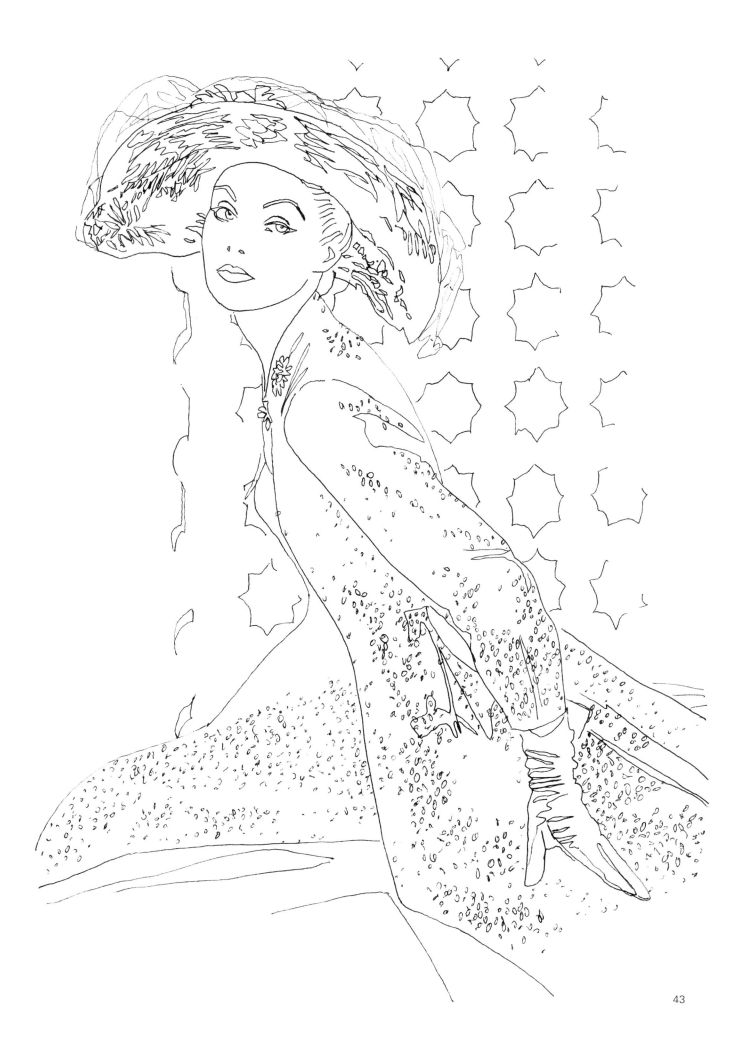

43

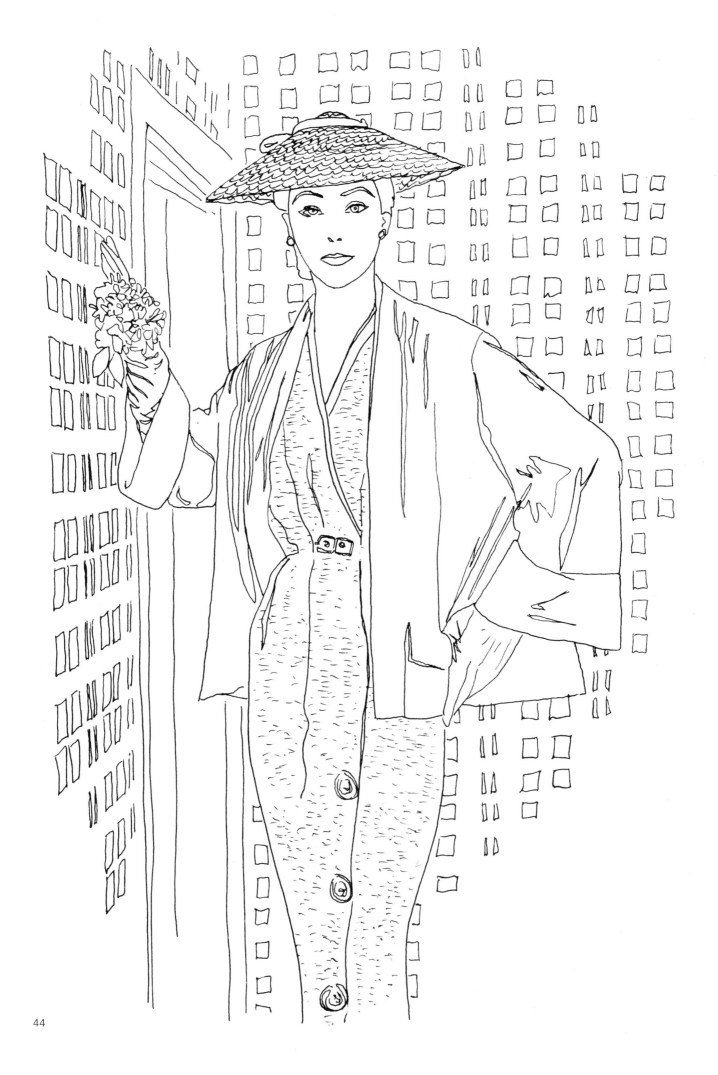

← June 1951
Some clothes, like people, have a single purpose in life: others are at ease anywhere. The piqué coat, bought as part of one inspired outfit, with an eye to several more, it tops jeans or cotton evening dress with undiminished aplomb. Note that cotton takes you non-stop round the clock. By Atrima. Worn with coolie hat.

October 1951
A bow across the bodice of…an evening dress. Dior's monochromatic dress in featherweight creamy brown net. Gilt crescent moons, graduated in size, carry the eye up to the molten bodice; a brown velvet ribbon, slanting to a bow, holds it there decisively.

June 1954
The prettiest summer for
years. A knee-length nightdress
in white nylon georgette, with
grateful acknowledgements to
ancient Greece; satin bound at
the tunic neck, satin-ribboned
from bosom to waist. At
Elizabeth Arden. Cushions
from Liberty's.

→→ **December 1951**
A Lanvin-Castillo ball dress of
yards of white shirred tulle with
silvery bugle beads hanging
like showers of rain all over it.
A wonderful floating confusion
of red tulle scarf is caught at the
shoulders and wrists to make
sleeves. Revlon's Misty Coral
lipstick and nail enamel.

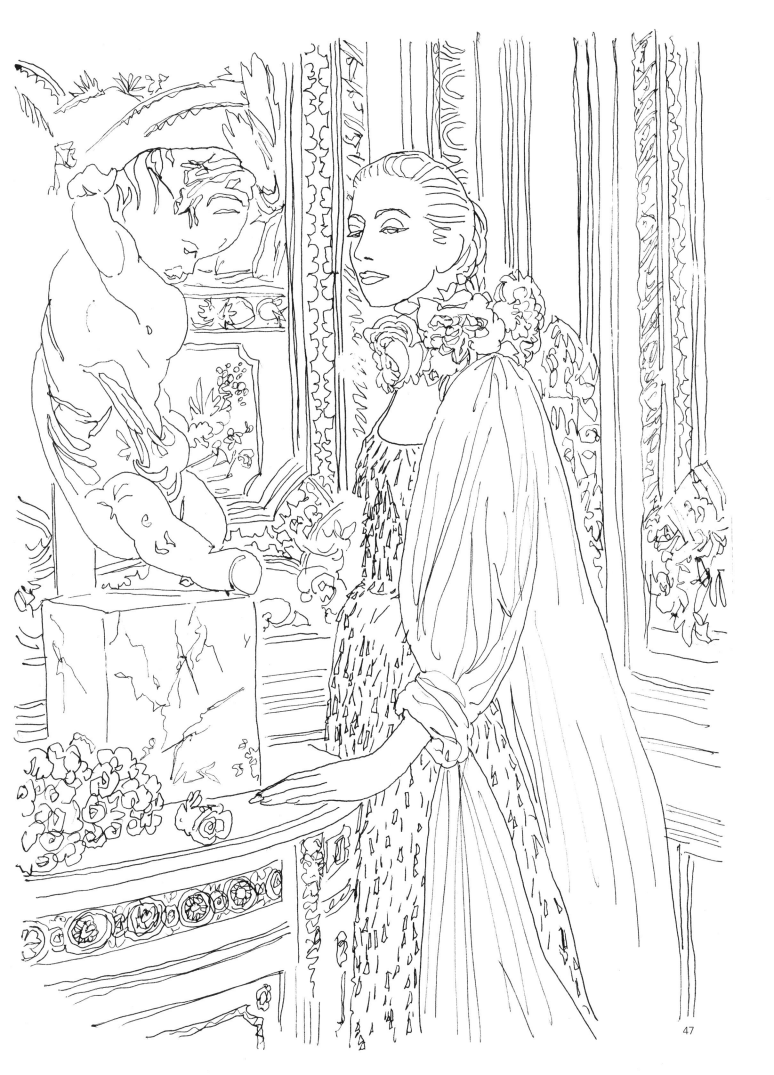

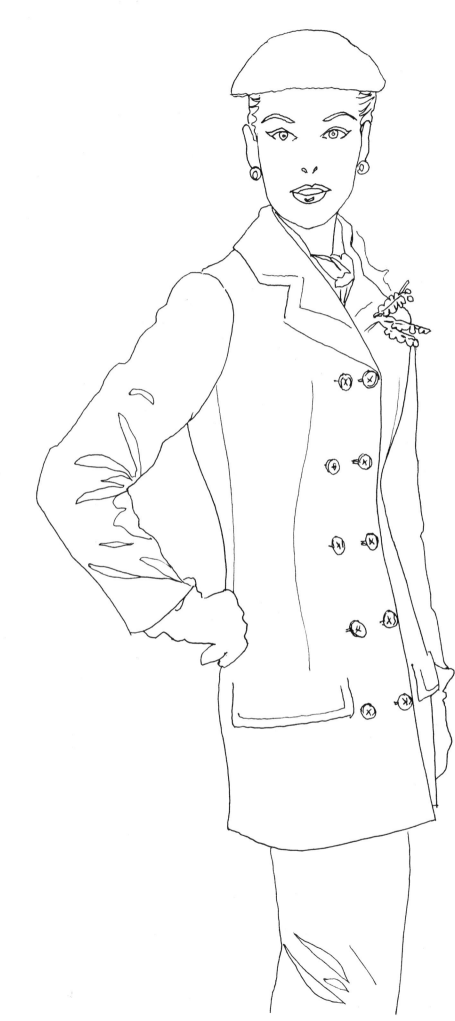

September 1954
The long flat line in suits. Elegance sums up the season: elegance sharp and clear-cut, achieved by taut, finely bred tailoring. A long gently curving jacket, unbroken to the fingertips, narrow chest and shoulders, slender skirt – this is Dior's newest look; here in green-grey Isle of Bute tweed.

→ **March 1952**
Wide Skirt – Narrow Shoulders. Hardy Amies' beige slub-worsted dress. The immense, gored skirt falls from a deep pointed bodice yoke; is nipped at the waist by a black patent belt; borne out below by a canvas lining. Sleeves cut in one with yoke to minimise the shoulders. Beige hat: Vernier.

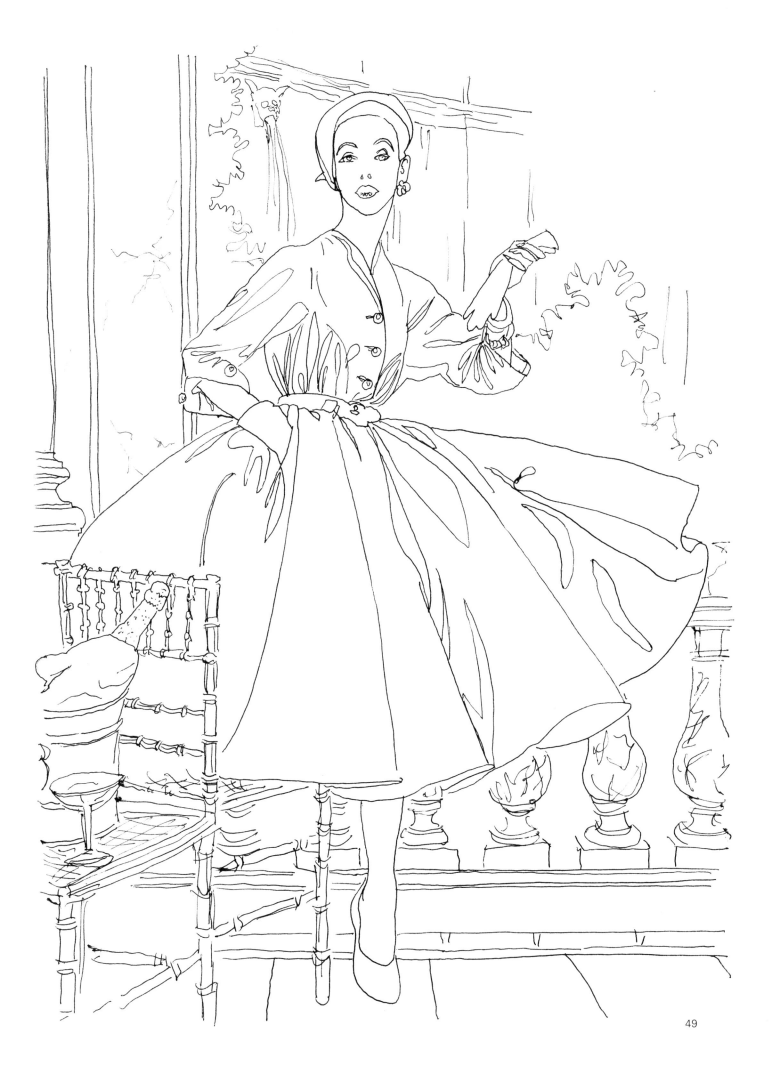

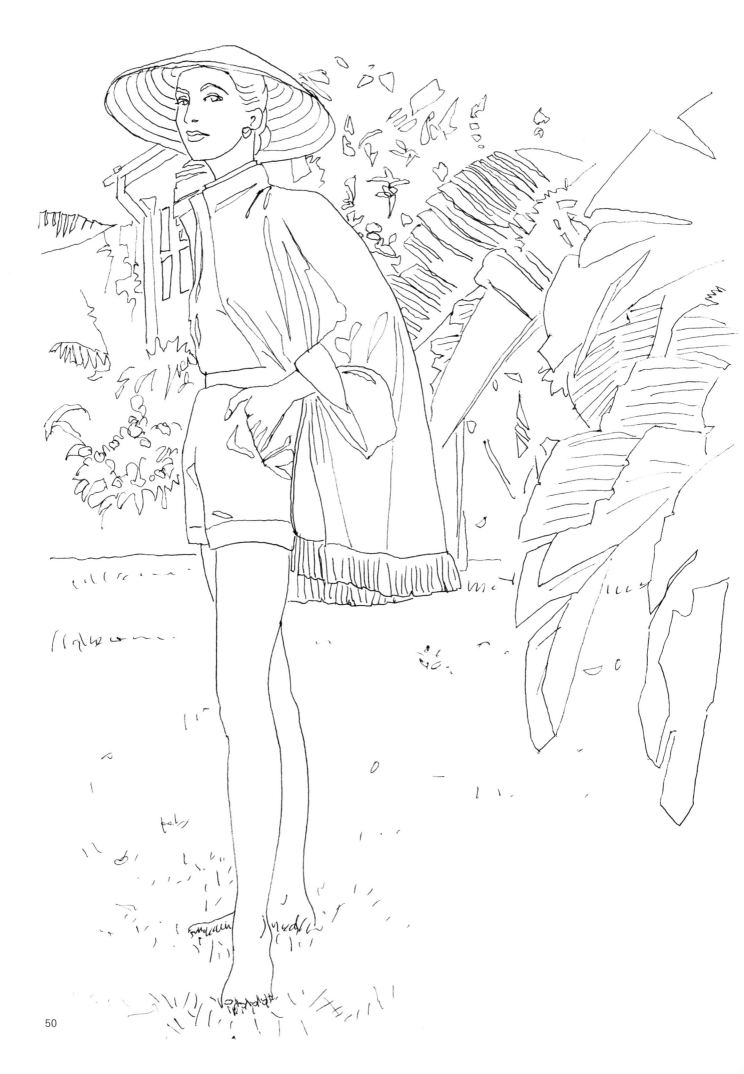

← **May 1952**

May 1952

Destination: Sunshine. Beach
Clothes. Bright new play clothes,
caught in the sun's spotlight.
In a luxuriant Australian garden,
a three-piece linen fibre play-suit
composed of deep-fringed coolie
jacket, brief cuffed shorts, yellow
shirt blouse. By Spectator Sports
at Simpson.

September 1954

In Paris. The flat-bosomed line
at Dior...the effect childlike,
demure. One of his entrancing
short dresses, like a Degas
dancer's, in grey satin, again with
the long, smooth torso, the skirt
flaring from hip-level. Buckled
satin shoes: Delman-Dior.

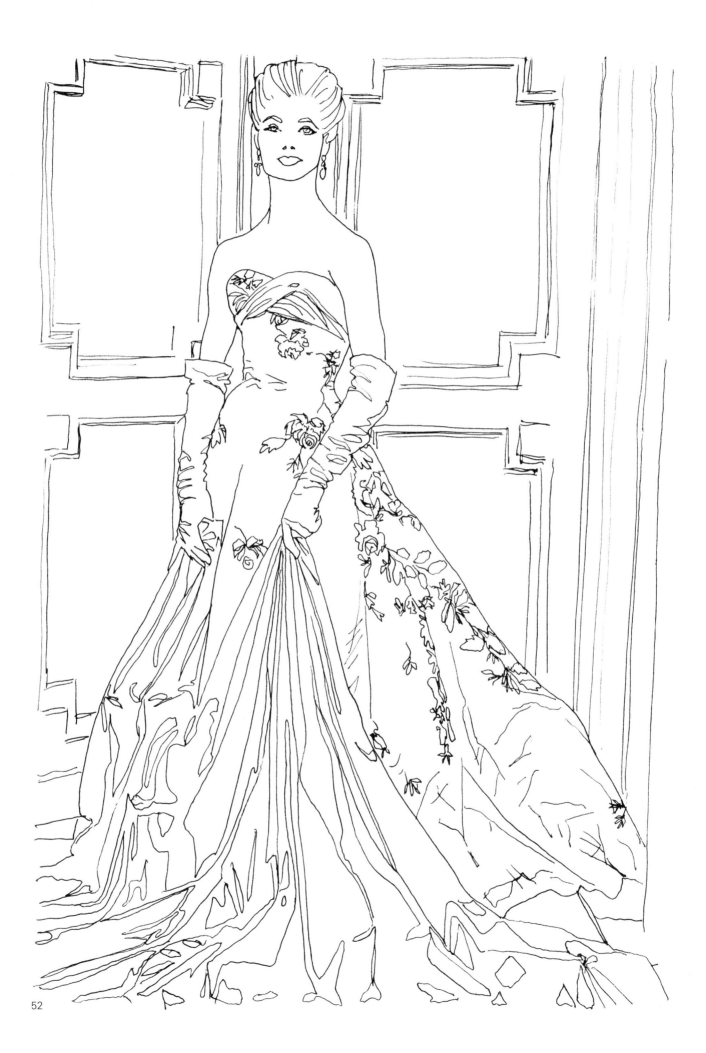

← **December 1956**

If you're dancing – a grand-entrance dress by Balmain in creamy, rose-embroidered faille, with a huge stole of olive green. The lipstick is Harriet Hubbard Ayer's Red Red.

November 1951

Clothes for winter travel. After-ski alternative. After-ski clothes now form a category of their own – planned to carry the vivid, clean-cut look of active ski-wear into the gay, informal evenings. The slim, trousered look…velvet for the tapered trousers, satin for the shirt. By Spectator Sports. Jewellery by de Farre.

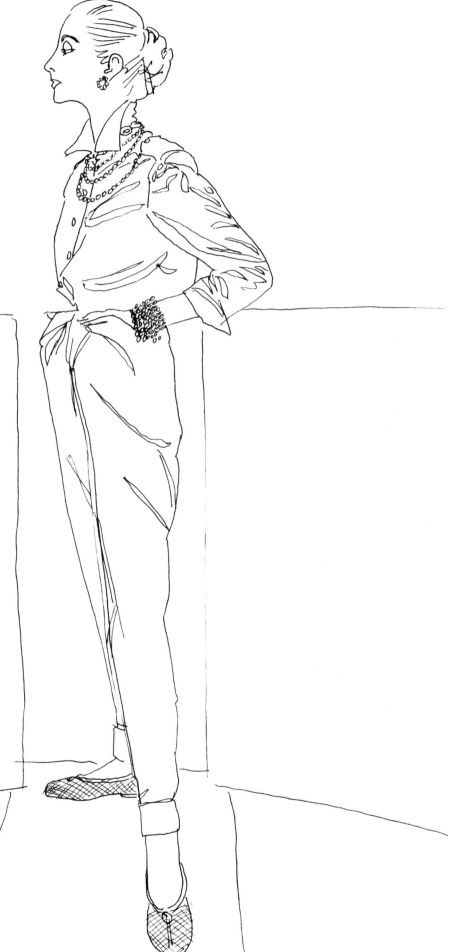

September 1955

In Paris. The Oriental influence.
Givenchy's black satin coat
reflects the Orient at its most
dramatic. Very full, it has a huge
cape-collar which ends in a low
bow in front. The satin hat, a
serene unbroken oval, juts out
at the back of the head.

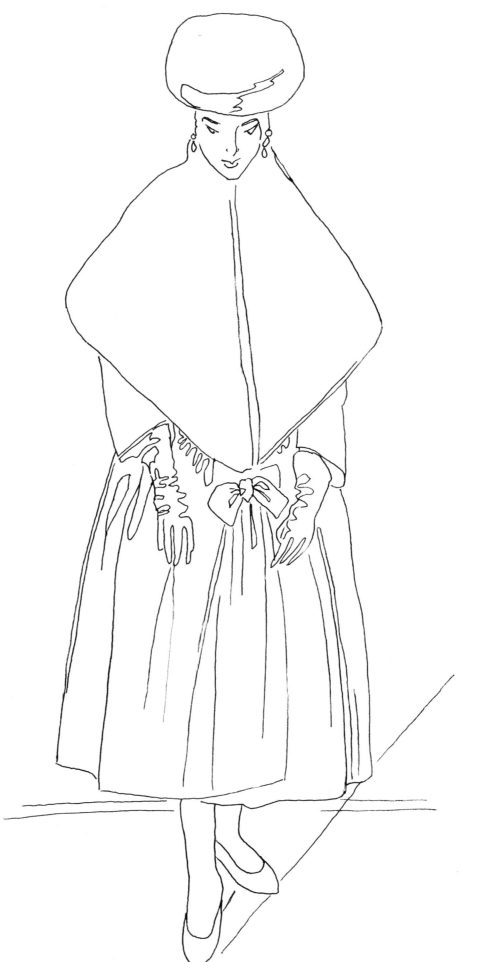

March 1957
Eastern after dark. Evening
Chinoiserie. Alluring as an
ivory tower, a sheath of heavy
white shantung, with Dior's
characteristic side-slit overskirt,
deeply slit sleeves. The slim,
unfitted cut, the waist-long ropes
of pearls, give a small-boned
fragility. Shoes by Dior-Delman
(Roger Vivier).

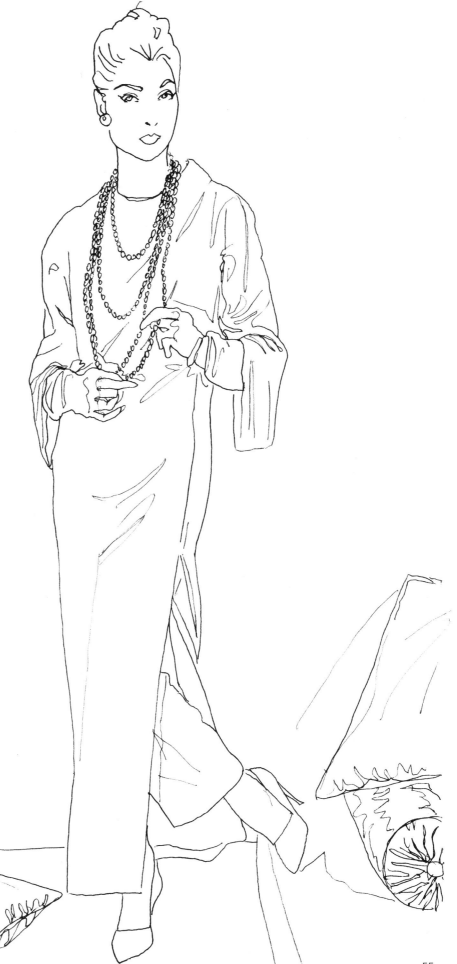

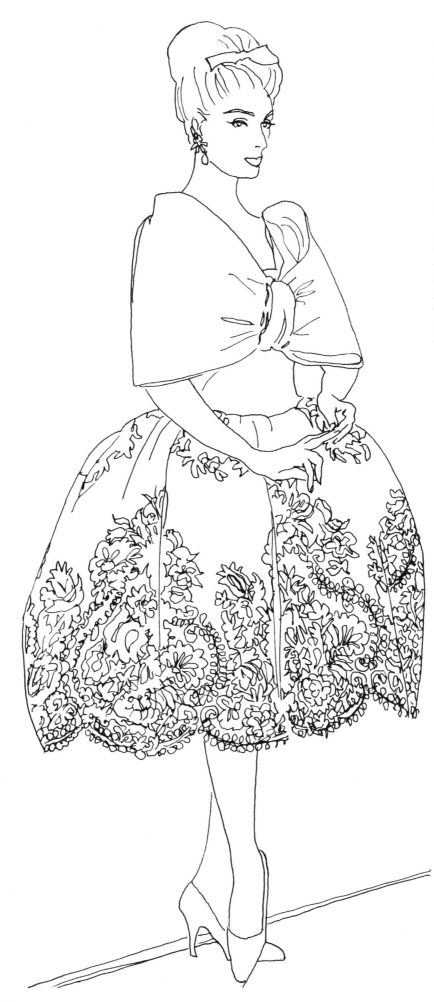

March 1958
The looks from Paris. A billowing skirt flat at the front, belling at the sides, a shoulder-wide bow – all accentuate the short skirt and slender body of Lanvin-Castillo's evening dress, in white organdie and black lace by Dognin.

→ **January 1954**
Country weekends: rough and smooth. Clothes must be informal – relaxing for aching, seldom-used muscles, willing to take a turn at the sink. Sweater top in blue, red and white printed cotton with white ribbed cuffs and turtle collar. Drainpipe trousers in grey wool jersey. Both by Spectator Sports. Gilt earrings and bracelet at Paris House.

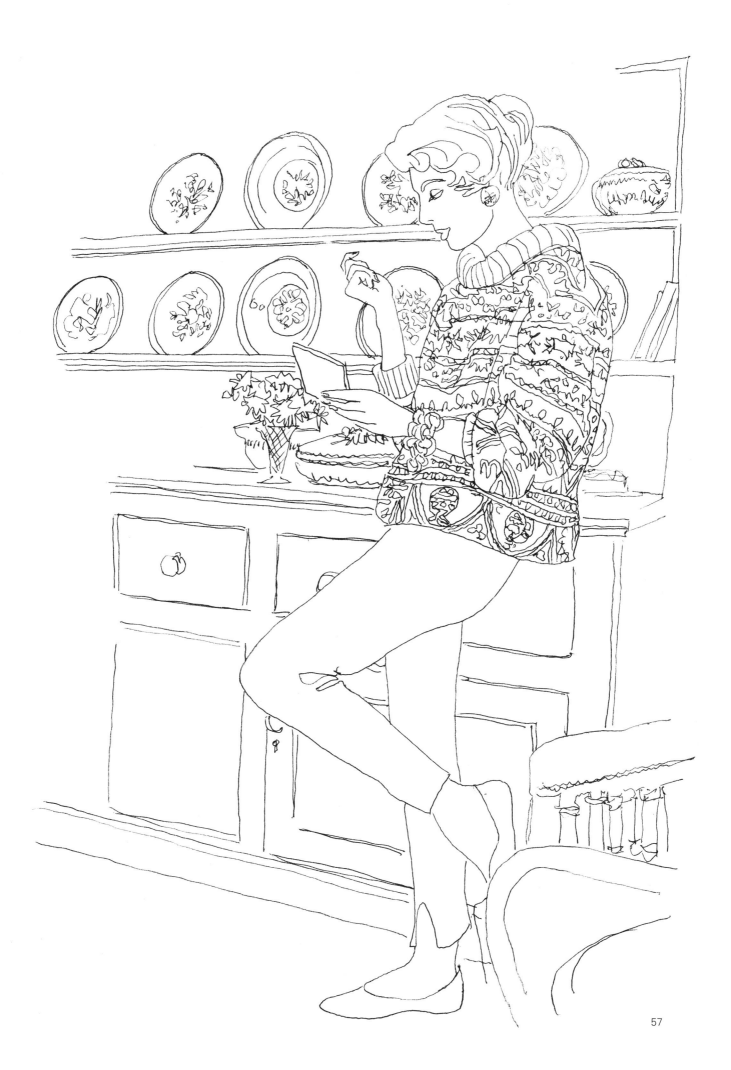

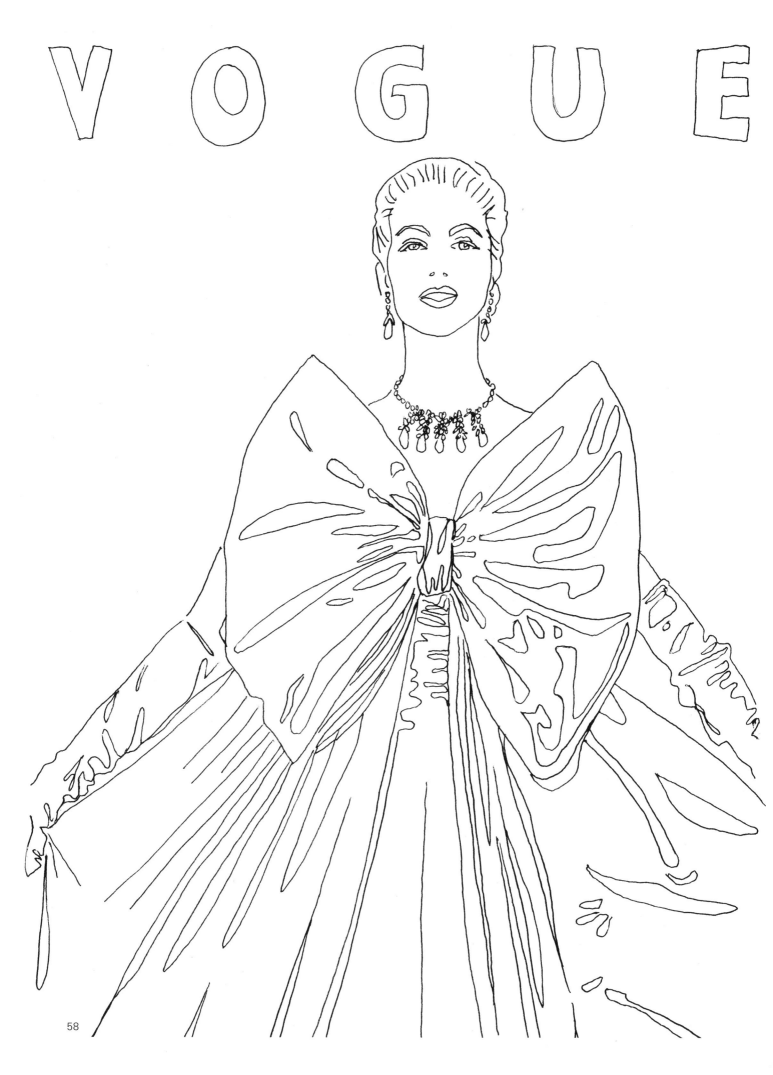

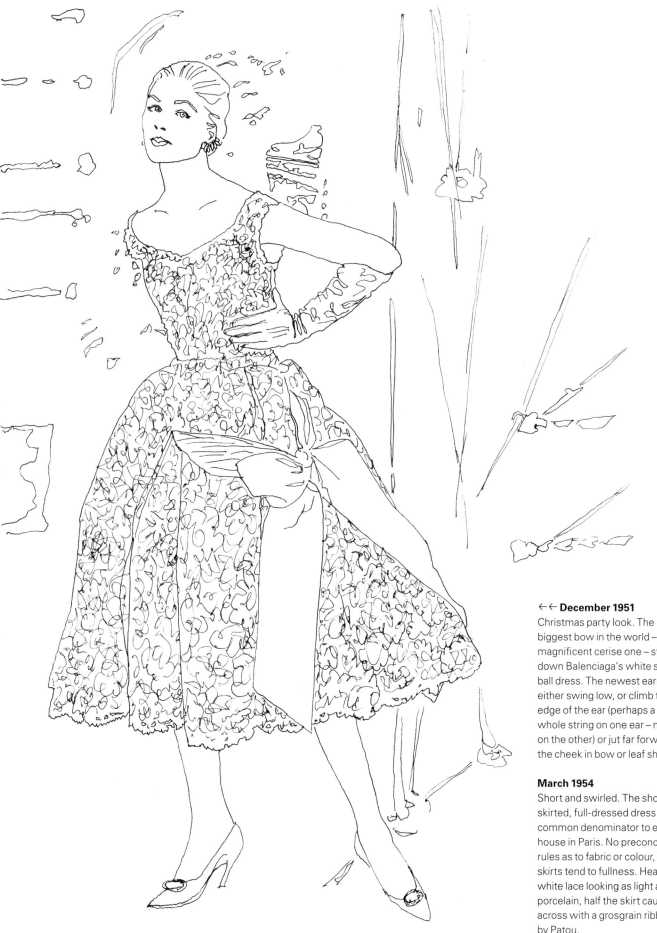

←← **December 1951**
Christmas party look. The
biggest bow in the world – a
magnificent cerise one – streams
down Balenciaga's white satin
ball dress. The newest earrings
either swing low, or climb the
edge of the ear (perhaps a
whole string on one ear – none
on the other) or jut far forward on
the cheek in bow or leaf shapes.

March 1954
Short and swirled. The short-
skirted, full-dressed dress is a
common denominator to every
house in Paris. No preconceived
rules as to fabric or colour, but
skirts tend to fullness. Heavy
white lace looking as light as
porcelain, half the skirt caught
across with a grosgrain ribbon;
by Patou.

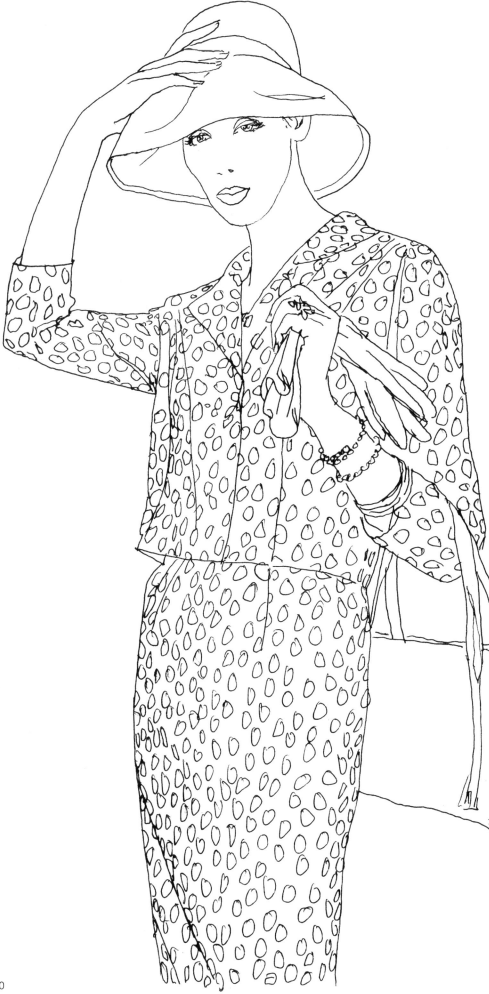

April 1959

Adaptability is a virtue inherent in the idea of the dress plus jacket – keyed to perfect pitch by beautiful accessories. A dress and jacket in navy slub silk, beige-spotted. Dress and jacket by Julian Rose. Brilliant coral cloche, by Simone Mirman; handbag in navy calf – newly neatly tailored, by Christian Dior.

→ **March 1954**

In Madrid…against one of the colourful tiled walls at the famous Villa Rosa restaurant – Pertegaz's brilliant green, paper taffeta evening coat (in Spain long evening dresses are only worn for big occasions – Embassy balls, the Barcelona opera). It is shaped like a tent, has an oval-necked shoulder yoke, and three tie fastenings.

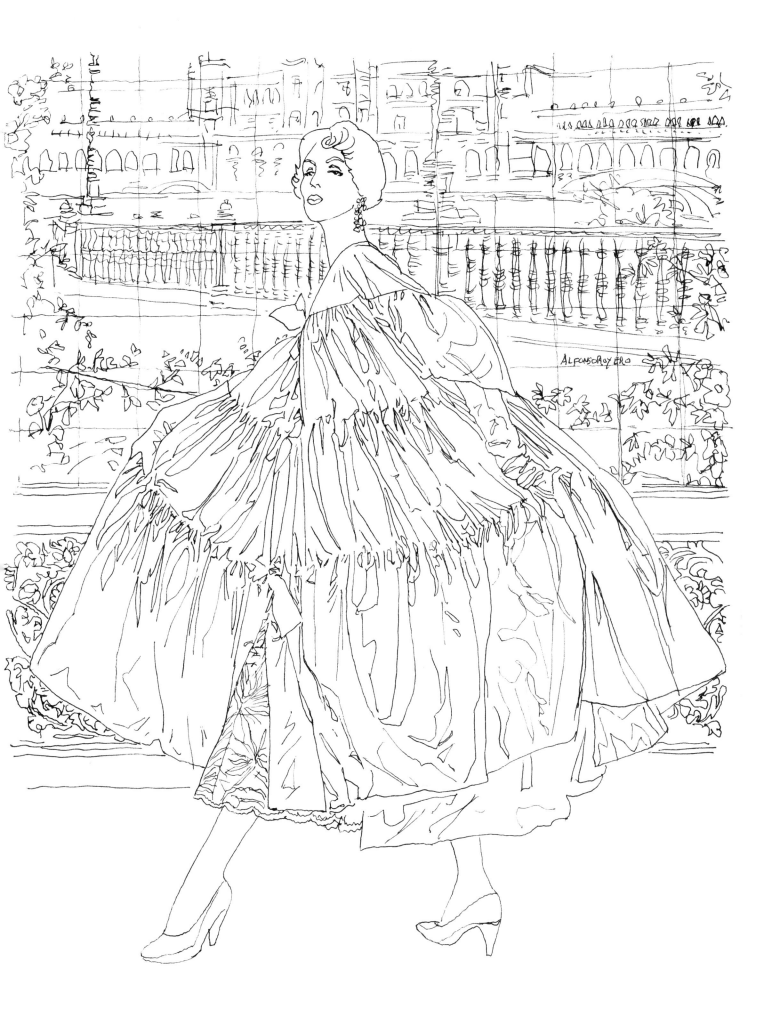

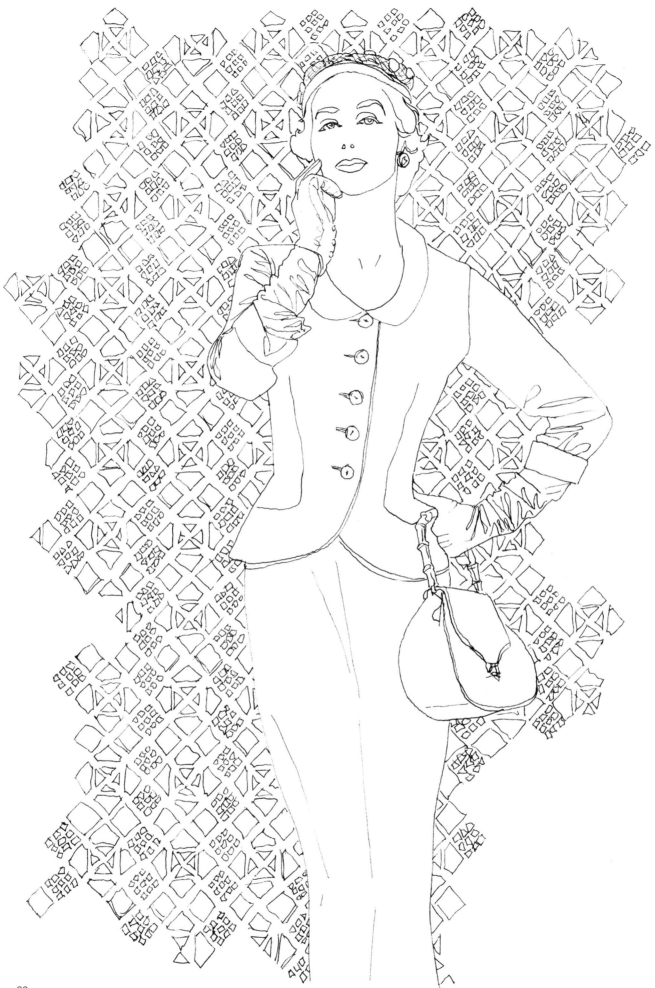

← **April 1954**
Blue plus green again –
blended into one colour
in a crease-resistant Irish
linen by Moygashel. Perfect
for a fitted summer suit.
Accessories: cool, pale,
alabaster. Tiny straw hat by
Dolores. Luxan hide bag,
bamboo handled at Russell &
Bromley. Suede gloves at
Dickins & Jones. Wallpaper is
a copy of one in the Regency
Pavilion, Brighton.

October 1955
One proof that individuality *is*
the fashion – the renaissance of
Chanel, the greatest individualist
ever to work a bolt of cloth. See
her simple jersey suit, simple
silk shirt, and big scene-stealing
jewels – a look that springs to
fashion life on the woman who
brings it the right kind of look:
enormous casual chic.

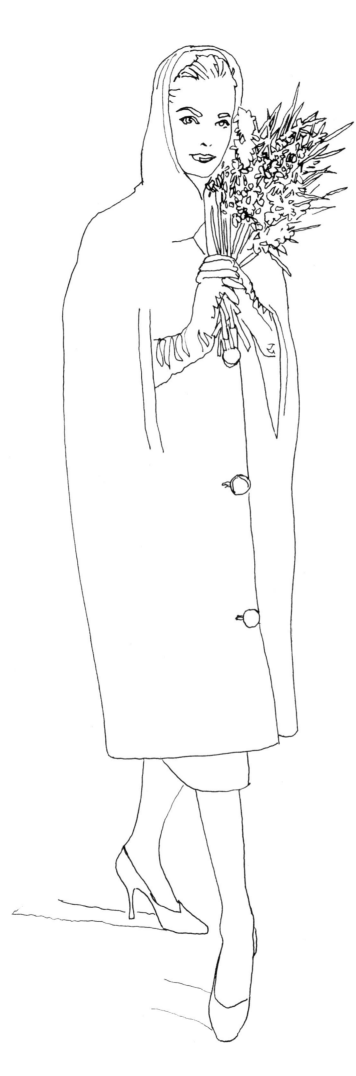

January 1957
All-changed fashion coverage: this is a cape, and done in black and white heavy tweed – two signs of 1957 change. It's narrowly cut, and has a hood which could relax back into a cowled collar; the slim skirt is in the same tweed; from Jaeger.

→ **June 1954**
The prettiest summer for years. This is delightful news for the Englishwoman, who can now be as pretty as her husband wishes. Miss Natasha Parry, wife of Peter Brook, and a great beauty…illustrates here how prettily flowers go to the head: a cap of white marguerites. Hat by Rudolf.

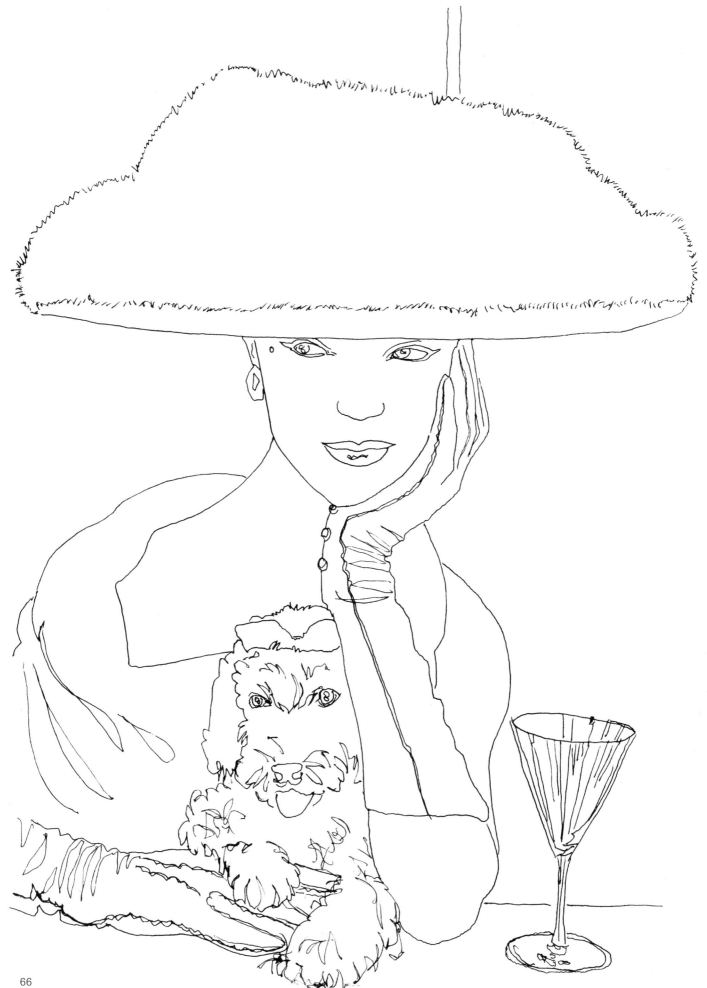

← **January 1954**
Blue-moon hats from Paris. Just occasionally, the party orbit includes hats like these; highly individual, proudly conspicuous, sophisticated as poodles. Characteristically, here, they run to extremes of size, use affluent texture contrasts. A flat roof of black velvet, deep in a snow-drift of white swansdown, by Balenciaga.

March 1958
The look from London. The prevailing mood is ease and a relaxed, undemanding sense of fit...The low-bloused, high-necked sheath: Hartnell evokes the '20s with a dress of milk-white crepe, shimmering with beads, which fringe the hem.

March 1954
The biggest news is personality news: Chanel's reopening. Her collection is the talk of Paris, with opinion violently divided. The Chanel look 1954. Her hallmark: an easy casual jersey charm. A navy suit with squared shoulders (note the padding), a comfortable waistband, a tucked, buttoned-on blouse, a typical neck-bow, and a back-of-the-head sailor hat.

→ **August 1957**
Into-autumn dresses. The one-piece dress, in beige wickerweave wool with a high, neatly-cowled collar and wide cuffed sleeves, by Linzi; the heightened turban hat in soft ginger melusine by Hugh Beresford 'Town and Country'; the T-strap shoes, taupe suede and shiny black patent, from Dolcis.

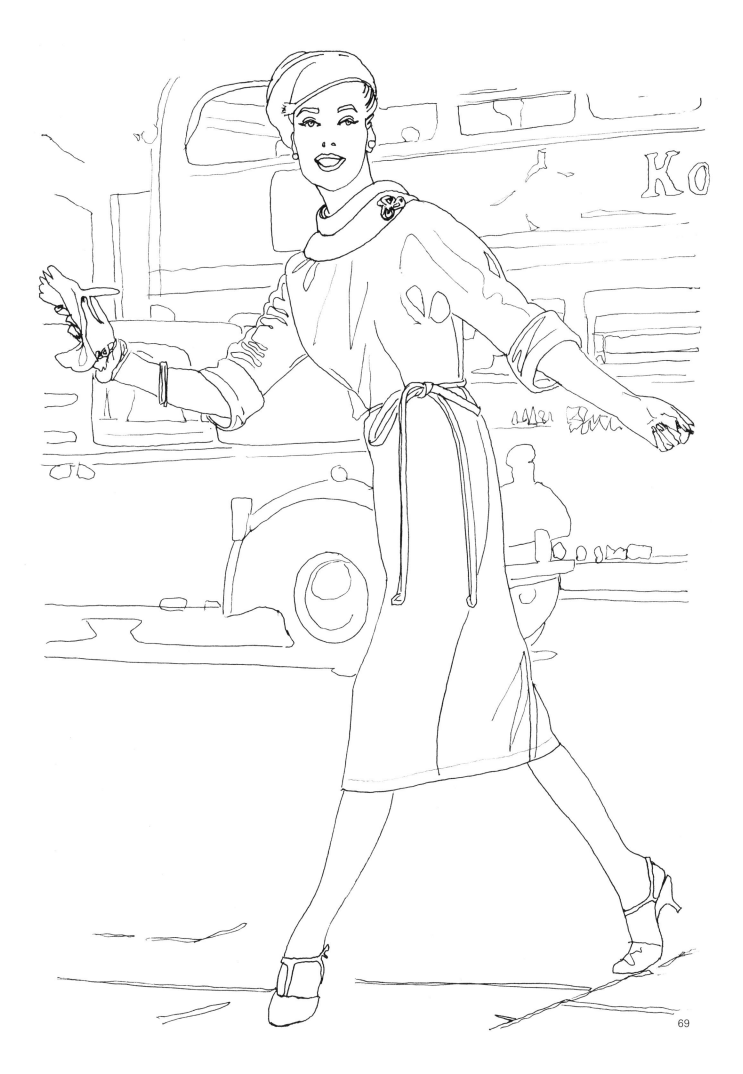

October 1957
How to be a well-dressed audience. Graceful compliment to a fine performance: a dark green lace jacket, collared in mink, over a matching short dress with a camisole top (for dancing afterwards). By Susan Small. The side-blown brown tulle turban is by Rudolf. Rhinestone earrings and bracelet, both by Adrien Mann.

→ **February 1957**
Against traditional blue tiles in a Portugal garden, the True Blue story opens with the very newest classic cardigan (pouched with a drawstring waist) in cashmere; over a paler worsted cord dress, both by Jaeger. Hat by Otto Lucas. Gloves at Harrods. Necklaces in two blues and earstuds: all by Adrien Mann.

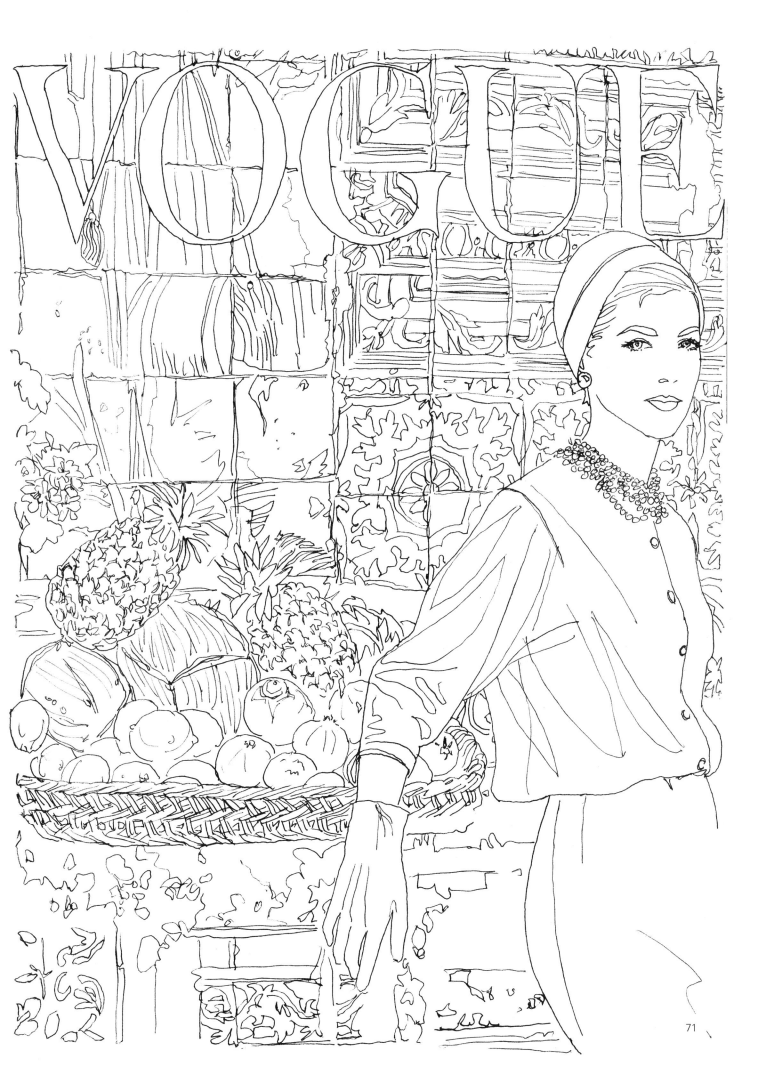

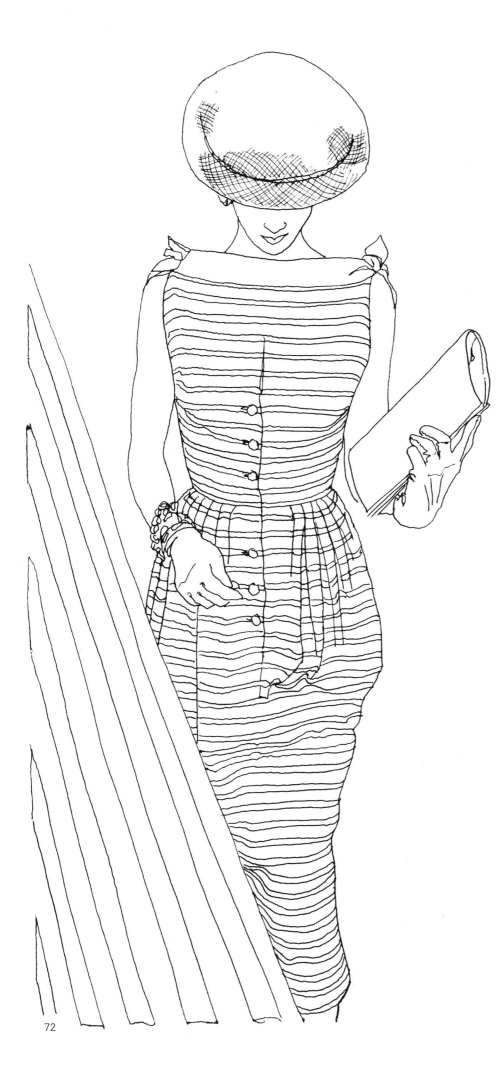

July 1954
Stripes step out. We expect them on the beaches: now they're everywhere. Here used horizontally, white on navy blue, for a cotton-jersey dress with a dual personality. Plus hat and gloves it goes to town; minus both, it's a casual sundress. Dress by Spectator Sports. Navy and white pancake hat by Simone Mirman.

→ **July 1956**
Ostend to Venice, '…drifting in a gondola…' This suit in pale blue knitted silk had just the right formality for Venetian sightseeing. We bought the gondolier's hat for a song. The beautiful pearl and turquoise bracelet came from Missiaglia, a superb jeweller in Piazza San Marco. Knitted suit by Rima. Handbag in yellow nappa leather by Jane Shilton.

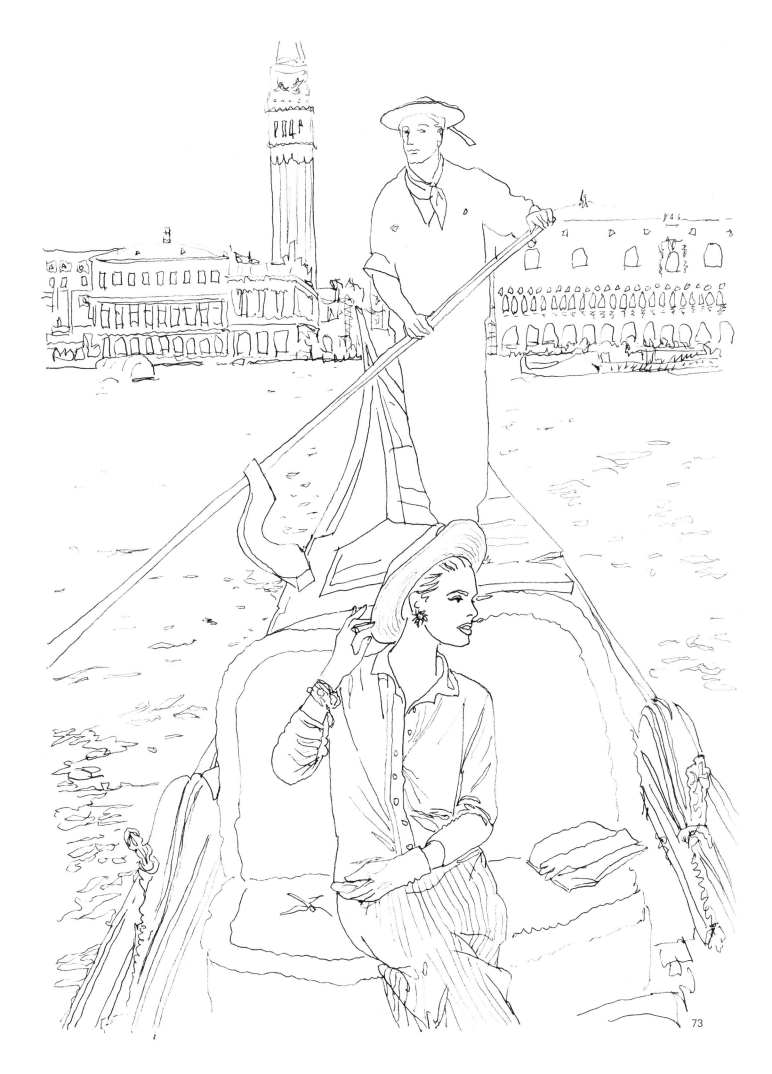

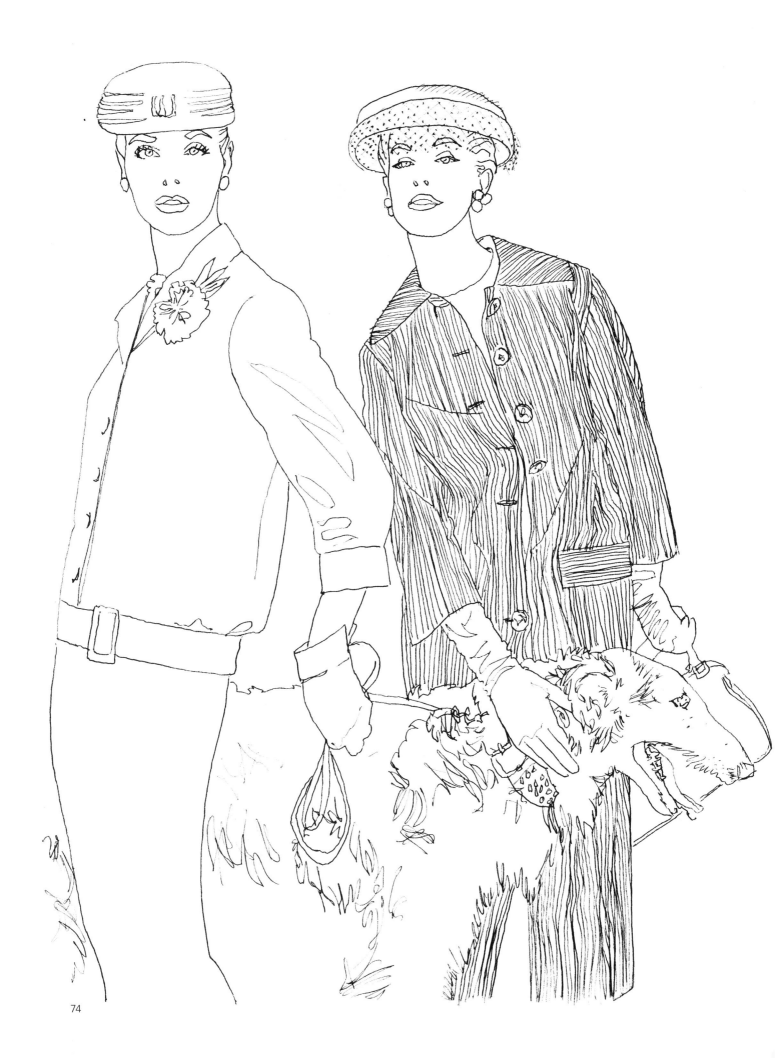

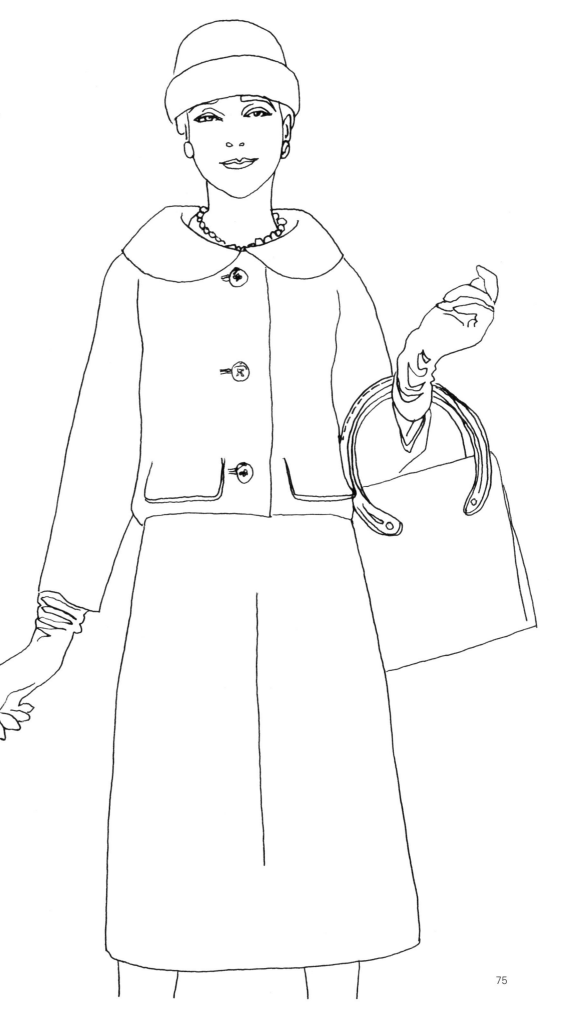

← **January 1956**
New, city-bred cottons. *Left*: a black and white three-piece. The jacket in white piqué; the vest-fronted blouse, striped lawn, the skirt, black piqué. By Horrockses. White suede toque by R.M. Hats. *Right*: The man-tailored look – stockbrokers' stripes for a precision-cut coat in (believe it or not) cotton. By Horrockses. The black and white straw hat is by Otto Lucas.

August 1958
Suit-thinking on trapeze lines, but viewed now in terms of winter-weight wools, its new found elegance depending more on cut, less on pleats and under-cover stiffening. Here, the cone skirt and faintly widening jacket of a suit in spinach green wool, with a cloche of almond green velour. Suit by Christian Dior-London. Hat by Christian Dior.

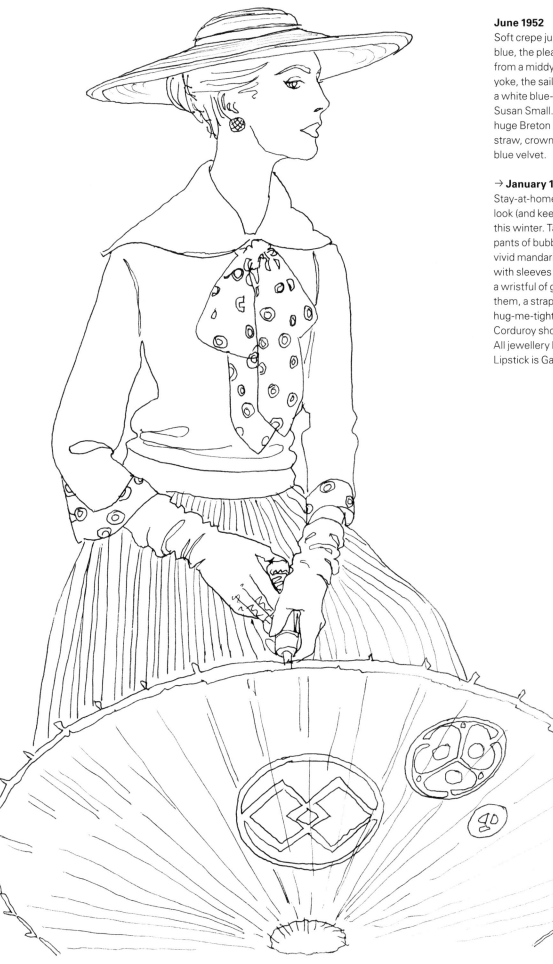

June 1952
Soft crepe jumper in navy blue, the pleat skirt falling from a middy-line, cuffed hip-yoke, the sailor collar tied with a white blue-ringed bow. By Susan Small. Simone Mirman's huge Breton hat in black straw, crowned and edged in blue velvet.

→ January 1952
Stay-at-home-stars…ways to look (and keep) warm at home this winter. Tapered at-home pants of bubble quilting and a vivid mandarin-collared bolero with sleeves sawn off to display a wristful of gilt bracelets. With them, a strapless, black jersey hug-me-tight. All from Harrods. Corduroy shoes from Gamba. All jewellery by Burma Gem. Lipstick is Gala's Red Bunting.

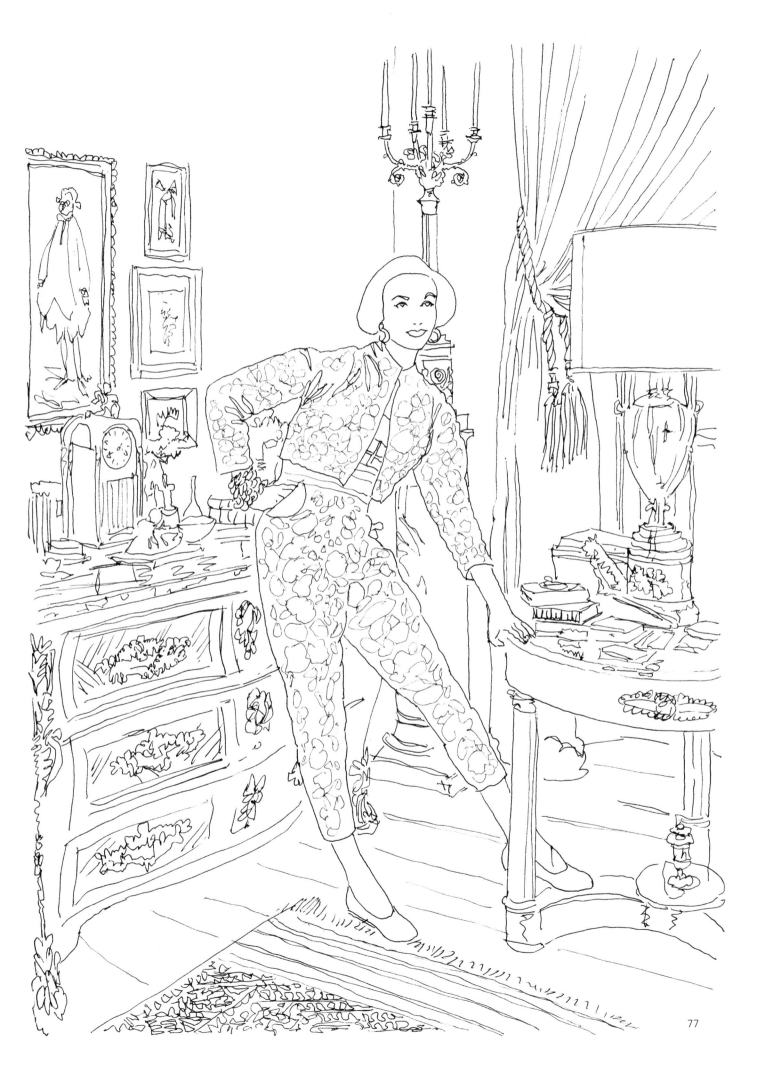

VOGUE

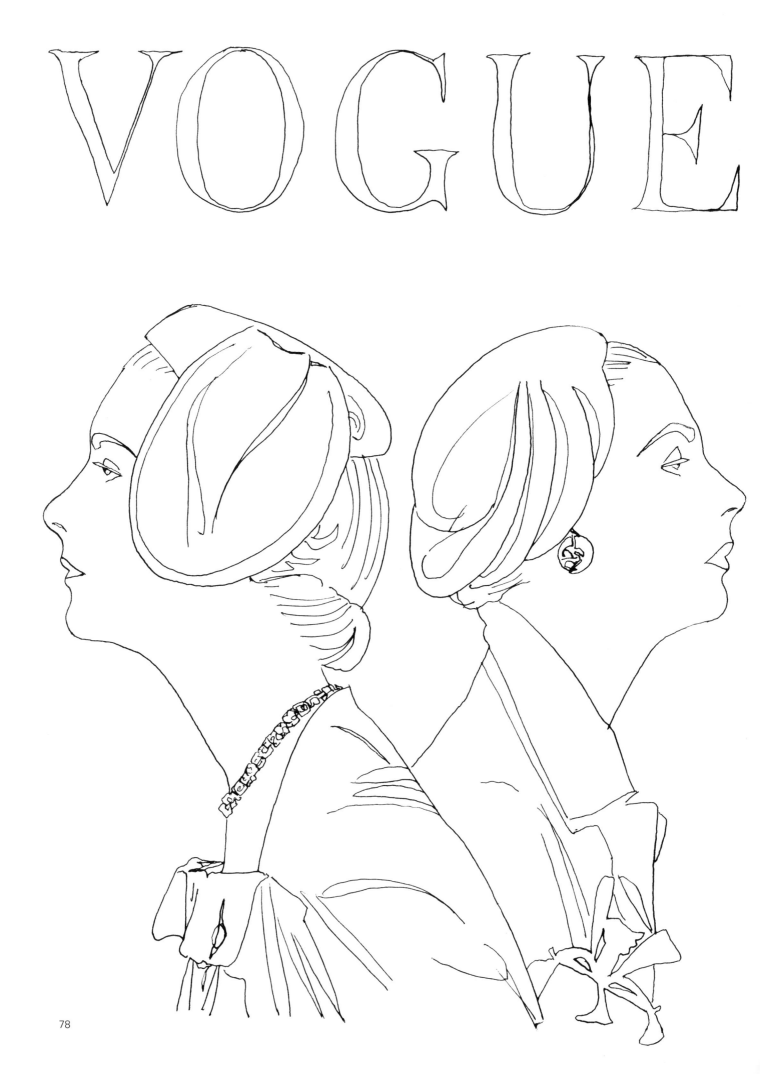

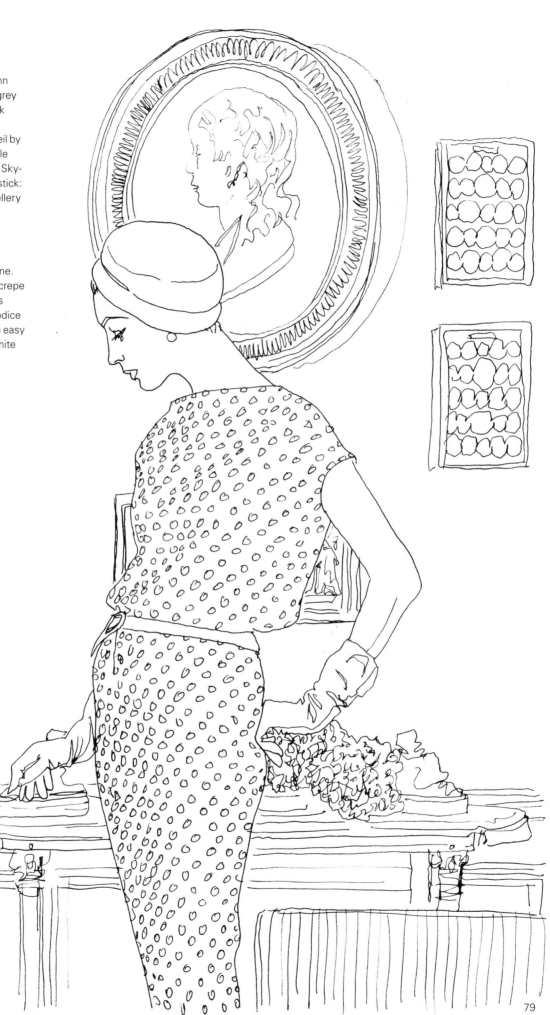

← October 1954

Spinach green – new autumn shade. *Right*: Spinach and grey tweed for a suit by Frederick Starke. Burnt orange hat by Otto Lucas. Lipstick: Vermeil by Lancôme. *Left*: Spinach faille for a dress by C.D. Models. Sky-blue hat by Otto Lucas. Lipstick: Pompadour by Payot. Jewellery at Paris House.

March 1956

The Paris Collections. Soft blousing makes a new outline. This year's dress – in black crepe de Chine, white-spotted, its skirt a narrow sheath, its bodice spilling over the waistline in easy fullness: with it, a cuffed white piqué beret. Both by Patou.

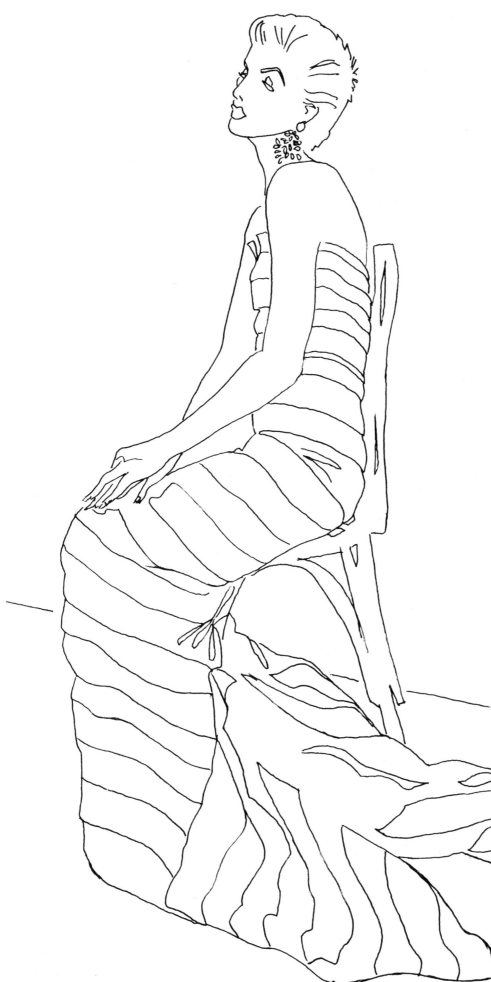

January 1950
Comtesse Alain de la Falaise (daughter of Lady Birley). Elegance is a sinuous length on her body, which falls into attitudes of great grace. She likes big earrings, striking clothes: such as Paquin black and white stripe fishtail taffeta. She takes some time to learn how to wear a dress.

→ **September 1955**
In London. Michael cuts his jackets short, curves them to hint at, not fit, the waist. Here a typical example in Otterburn Mill's black and white diagonally-striped tweed. The shoulder width is accentuated by a big pointed shawl collar and broad sleeves narrowing towards the wrist. Marigold velour hat by Valerie Brill.

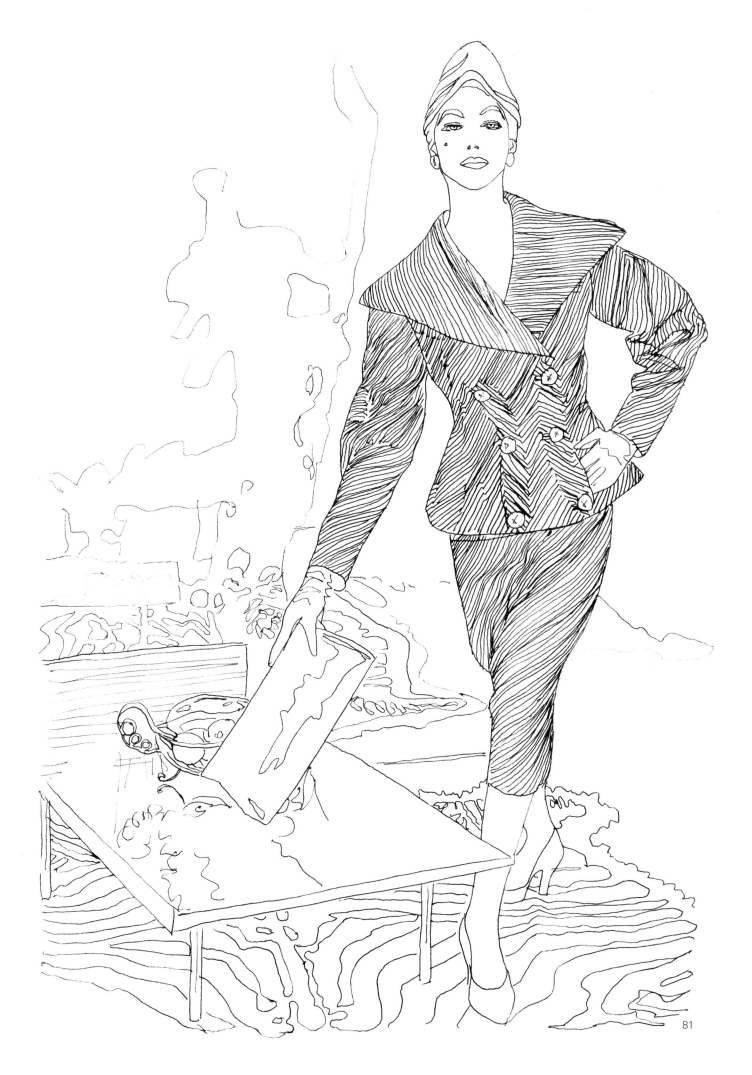

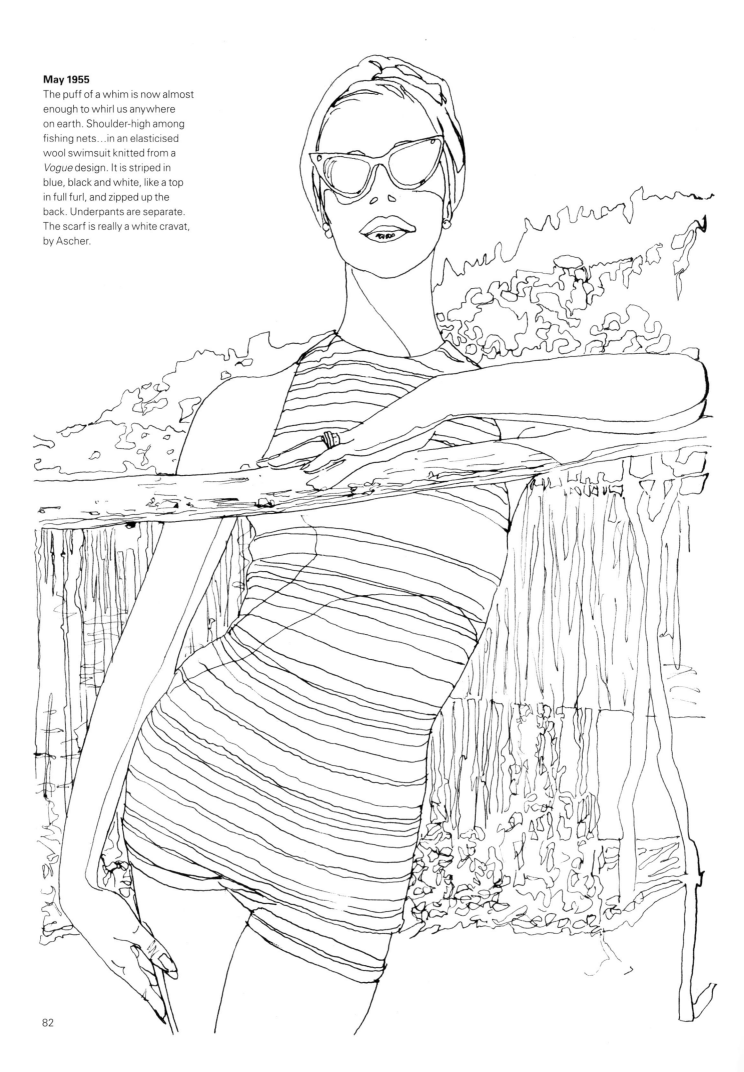

May 1955

The puff of a whim is now almost enough to whirl us anywhere on earth. Shoulder-high among fishing nets…in an elasticised wool swimsuit knitted from a *Vogue* design. It is striped in blue, black and white, like a top in full furl, and zipped up the back. Underpants are separate. The scarf is really a white cravat, by Ascher.

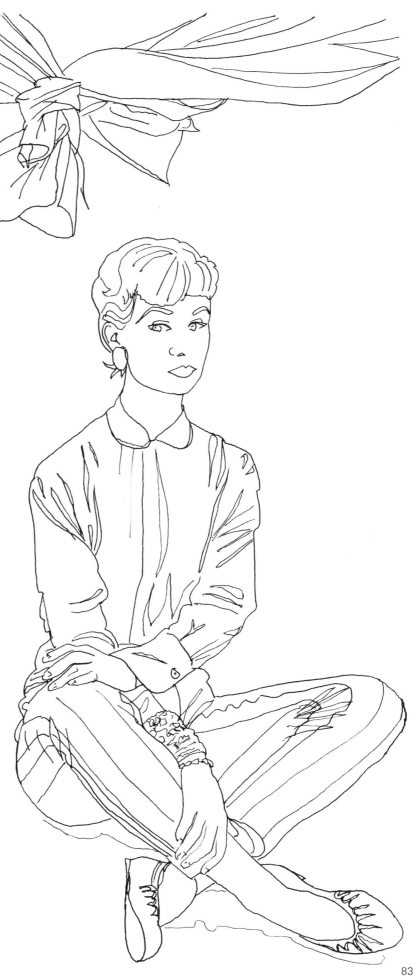

November 1954
Casual evening pant: in vividly
striped metallic-thread hopsack,
they taper slimly, are partnered
by a Goya-pink shantung shirt.
The slim woman's ideal from
sundown on. By Rima. Shirt
at Harvey Nichols. Gold-
embroidered velvet suede
pumps at Dolcis.

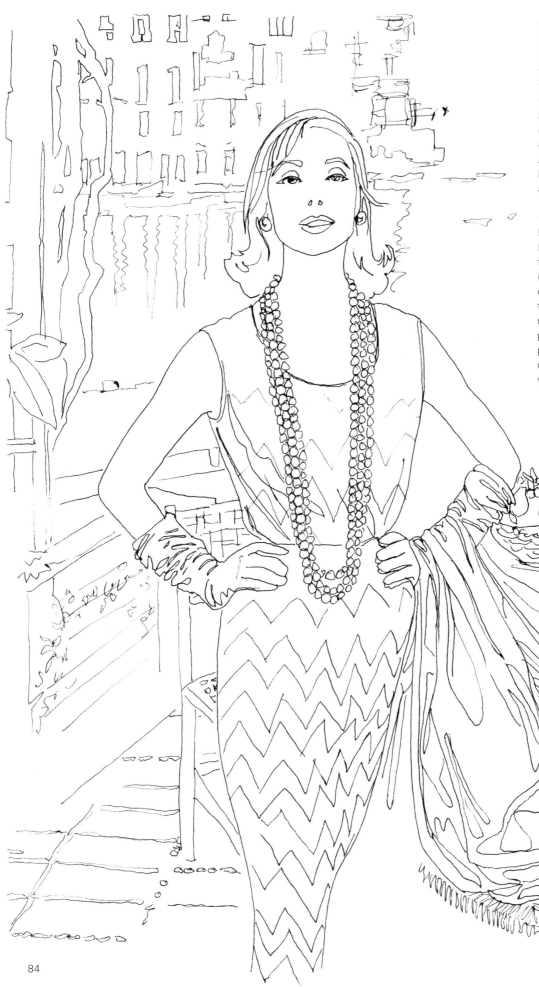

February 1955
Early sun. The pleated sheath, now a practical possibility in a variety of fabrics, and the best travelling companion of them all. Ours is of pale blue-grey Orlon and cotton, sleeveless, straight, durably pleated throughout in a chevron design. By Rembrandt. All jewellery and accessories by Fratti of Milan. Photographed at Portofino.

→ **May 1957**
First the suit… in navy blue Erinmore Irish linen – a slim skirt topped by an easy-fitting *vareuse* (an idea straight from Paris, and one of the most charming, easy-to-wear fashions we know). The neckline bare but for a five-string pearl necklace, by Adrien Mann, plus a souwester (of course) in coral straw, bound with navy velvet, by Dolores Glamour.

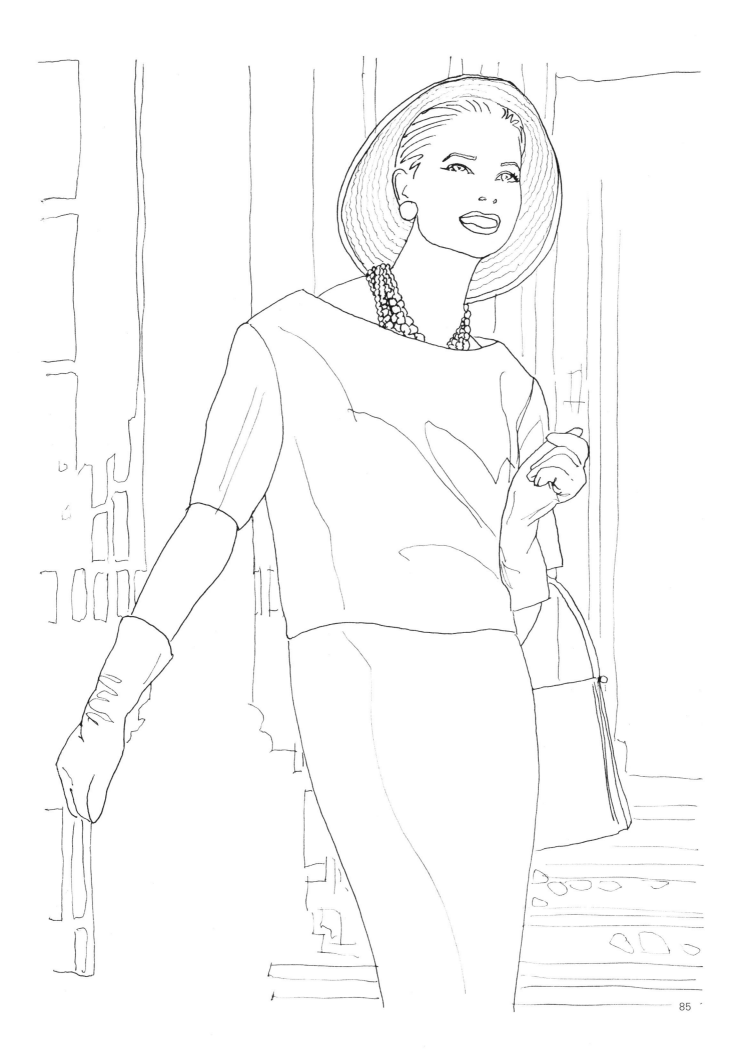

August 1955
For day, tunics with slim skirts add up to another coming fashion – the jumper suit. The two-thirds tunic: in shadow-striped grey brushed rayon, it has two hip-level pockets, is belted at the back. By Frank Usher. Plush helmet, by Dorothy Carlton.

→ **July 1955**
Pink has a new power: as a stronger, purer outcome of its old self it is a fashion force, and a sharp no to any feelings that pink's-not-for-me. Here, mouth and nails announce the news, with Revlon's Kissing Pink. The long sweater (waistcoat-seamed) is a higher echo; suede-finished cotton pants deepen the story. By Dorville.

May 1952
Plan for packing. Holidays are
almost upon us. There's still time
though, to make these clothes
we have chosen from the *Vogue*
Pattern range. Cool and fresh
looking, they will give confidence
to your summer wardrobe.
Scoop-necked sheath dress,
very spare and curved of line. We
made it up in black Irish linen.

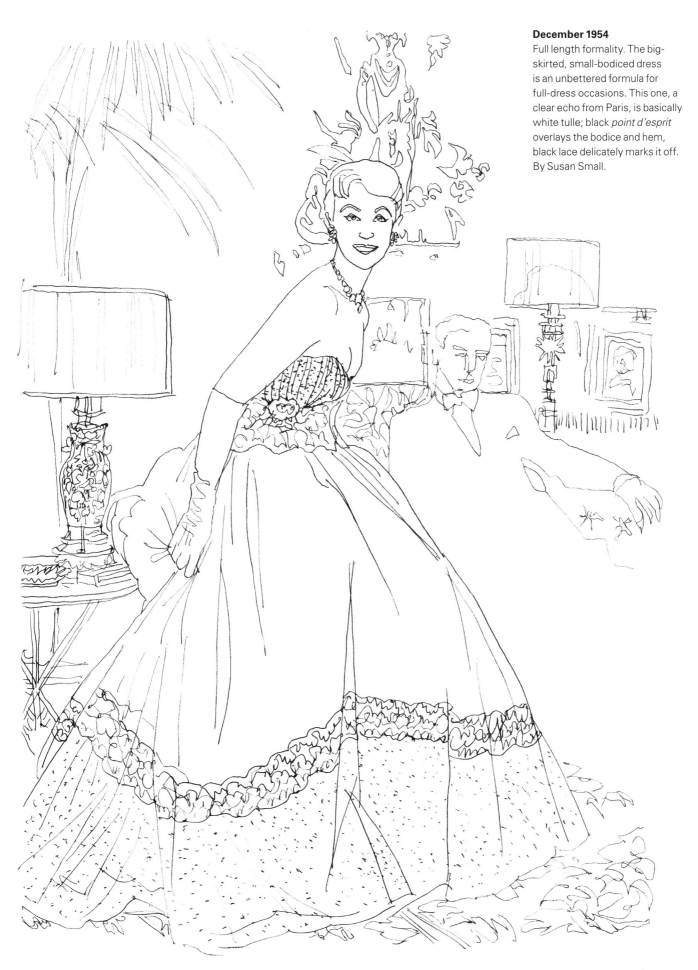

December 1954
Full length formality. The big-skirted, small-bodiced dress is an unbettered formula for full-dress occasions. This one, a clear echo from Paris, is basically white tulle; black *point d'esprit* overlays the bodice and hem, black lace delicately marks it off. By Susan Small.

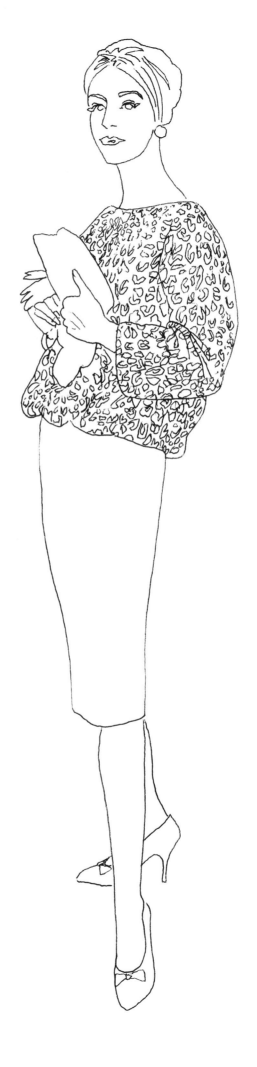

← **July 1954**
Sunblessed separates.
An apparent piece of
extravaganza that keeps well
within budget, yet whose
rose-garlanded charm is bound
to raise a pretty compliment; a
bloomer suit that welcomes sun
or sea – either with impunity; in
rose-pink, rose-patterned cotton
satin, banded with white wool
ribbing. Over it a man's-style
shirt, looking anything but
masculine. By Elegance.

December 1958
More than your money's worth.
A pullover…man's shape,
leopard-patterned, pouched
with elastic at the hip, at Levison
Furrier. For cocktails or dining out
back home: with a black jersey
skirt, at Dickins & Jones, and
black satin pumps, vamp bowed,
at Pinet.

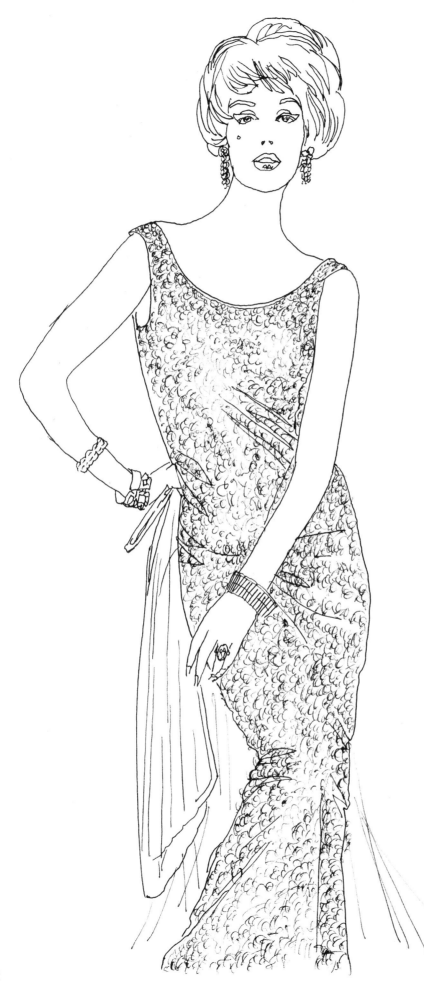

Mid-September 1958
Glamour girl. Shimmering gold
sequins seem to diffuse their
own light in a breath-taking
evening dress, by Frederick
Starke – chemise-y, floor long,
with a soft drift of matching
tulle falling behind. With it,
rhinestones galore and a golden
mop of wig.

September 1955
In Paris. Layers of chiffon float out into a great sweeping train from shoulder-blade level on Dior's evening dress. The bosom is high, moulded; the arc-shaped skirt rises almost to day-height in front.

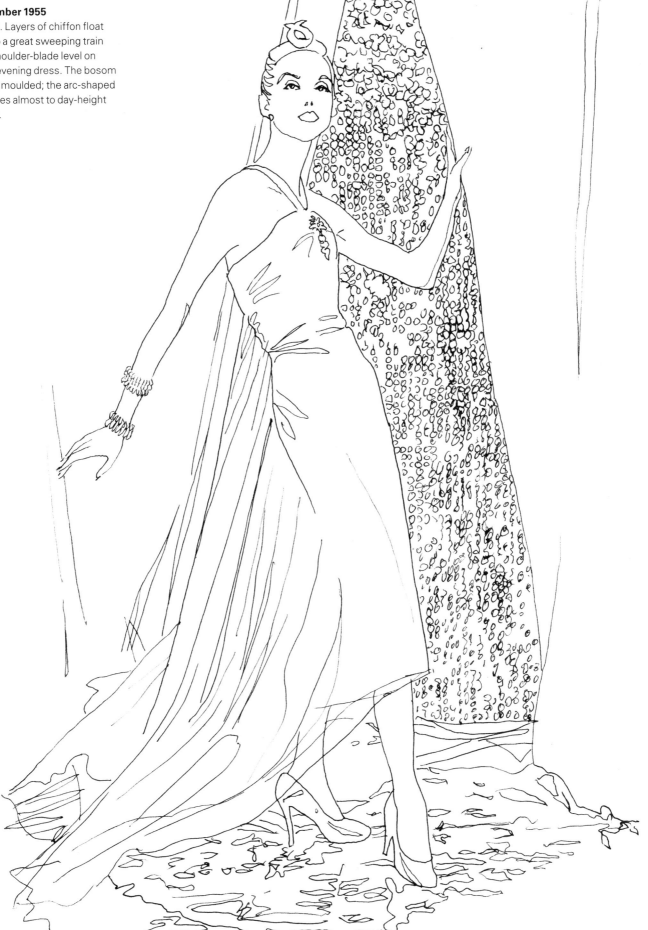

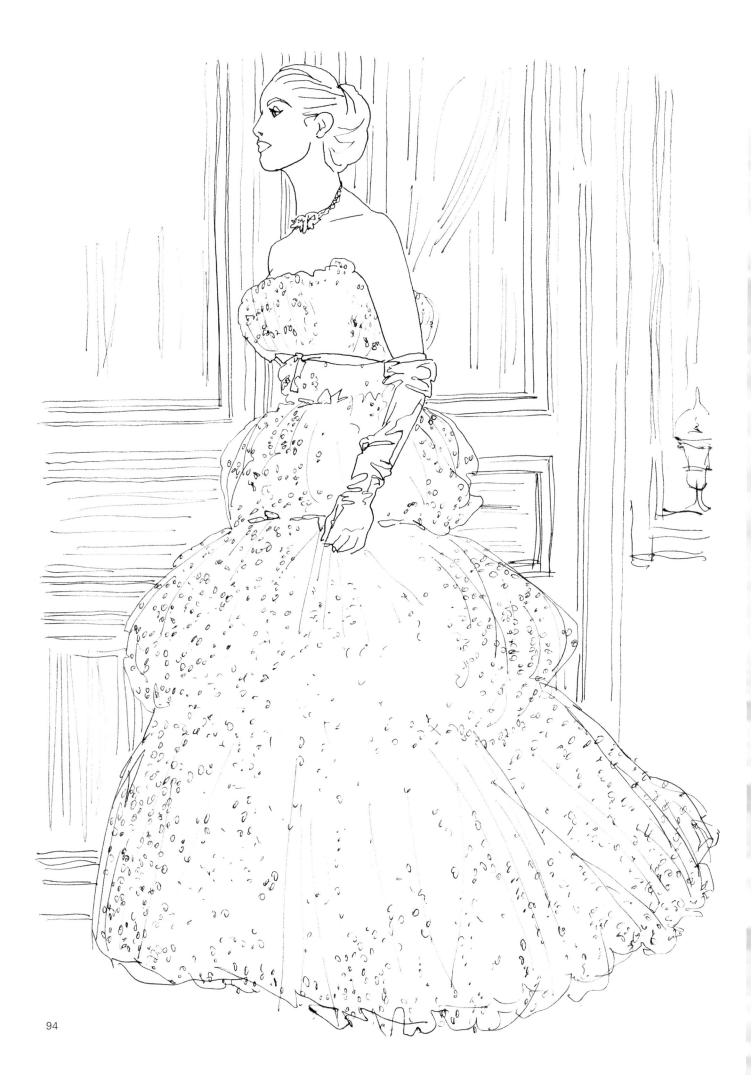

← October 1954
After dark: Spun-sugar flurries of white in Balenciaga's ball dress…is the other side of the coin, all frailty and moonshine, very, very feminine. It is as though the dotted net had been dropped in great whipped spoonfuls over the underlying shape.

March 1956
The Svend hats are the most sensationally beautiful in Paris. He makes two-tier turbans like cottage loaves, hats with sugar-loaf crowns and big turned-up brims: all big but light – because made in airy fabrics or lacy straws. Here, a deep drum of black net with a dotted net veil swathe flattering eyes (for Madeleine de Rauch); at Harrods.

95

Picture credits:

All drawings, by Iain R. Webb, are based on images by the following photographers © The Condé Nast Publications Ltd.

Cecil Beaton 2, 10, 40, 41, 47, 57, 58, 65, 72, 77, 80, 83

Henry Clarke cover, 14, 17, 19, 24, 28, 38, 39, 42, 45, 49, 52, 54, 55, 56, 59, 61, 63, 66, 68, 71, 73, 79, 82, 84, 87, 93, 95, back cover

Clifford Coffin 48, 51, 88, 94

John Deakin 15, 21, 31, 53

Anthony Denney 6, 13, 32, 36, 44, 50, 76, 89

Don Honeyman 9, 12, 20, 23, 34, 43

Donald Silverstein 4, 18, 35

Eugene Vernier 7, 8, 11, 22, 25, 30, 37, 46, 62, 64, 67, 74, 78, 81, 85, 86, 90, 91

Claude Virgin 16, 26, 27, 29, 33, 60, 69, 70, 75, 92

Front Cover:
November 1958
Vogue's special beauty offer. Have prettier skin in just 3 weeks.

Back Cover:
September 1955
In Paris. Sculpted satin. An obi sash tightly bound under the high bosom, one end thrown over the shoulder, the other falling down the front of the narrow skirt, gives an Oriental character to Dior's wonderful dress in pearl-grey satin.

An Hachette UK Company
www.hachette.co.uk

First published in Great Britain
in 2015 by Conran Octopus Ltd,
a division of Octopus Publishing Group Ltd,
Carmelite House
50 Victoria Embankment
London EC4Y 0DZ
www.octopusbooks.co.uk

Text and illustration copyright © The Condé Nast Publications Ltd 2015
Design and layout copyright © Octopus Publishing Group Ltd 2015

ISBN 978 1 84091 721 5

A CIP catalogue record for this book is available from the British Library.

Printed and bound in Italy

10 9 8 7 6 5 4 3 2 1

Publisher: Alison Starling
Creative Director: Jonathan Christie
Project Editor: Ella Parsons
Proofreader: Helen Ridge
Senior Production Manager:
Katherine Hockley

Author's Acknowledgements:
I would very much like to thank the team at Conran Octopus for making this book possible, particularly Alison Starling for her enthusiasm and passion for the project, and Jonathan Christie for turning my idea into such a good-looking, real-life book. I would also like to thank the team at The Condé Nast Publications Ltd, including Alexandra Shulman for her continued support, Brett Croft and Frith Carlisle for their much-appreciated dedication to the project, Ben Evans for his faultless organization and chic advice, and Harriet Wilson, who has made the experience a total joy (HOPE we can continue the collaboration). Thanks also to Julian Alexander for embracing the initial idea with great gusto. I would like to especially thank Rosemary Harden and Elaine Uttley at the Fashion Museum, Bath, for access to their wonderful collection, also Central Saint Martins, London College of Fashion and Royal College of Art (notably Sarah Dallas) for the use of their libraries. I could not have made this book without Gregory Davis and Mark Clarke. I dedicate this book to every little boy who likes to colour in pictures of frocks.

ENJOY COLOURING YOUR OWN *VOGUE* COVER
#VOGUECOLOURINGBOOK